Table of Contents

Introduction

I am passionate about painting in pastel! Nature gives us so many beautiful pigments, which are used to make pastels. Think about that for a moment: All of these beautiful colors are derived from nature and carefully blended to make hundreds of wonderful pastels to choose from!

Artists have been painting with pastels since the Renaissance. By the eighteenth century, pastels had grown in popularity, and they were favored by many Impressionists during the nineteenth century, particularly Claude Monet and Edgar Degas. Some of their pastel paintings look as fresh today as the day they were painted, all those years ago. Today, with the increase in pastel choices and the developments in surfaces, pastel painting has never been more popular.

As an artist, I have tried many mediums, but once I picked up a pastel, that was it. One of the things I love about pastel is that it is a very "hands-on" medium, which allows you to interact with it and develop your own style of painting.

In this book, I will guide you through this wonderful medium, starting with the basic elements like materials and choosing a subject and then progressing to step-by-step exercises, which will enable you to use all of the tips and techniques you have learned.

When I first started painting in pastel, I was amazed at how quickly I could produce a finished painting. I hope you will be too! Let's begin.

I would like to thank my wife, Kate, for her photography skills, boundless enthusiasm, and encouragement in producing *Beginning Pastel*. Without her, this book would not have been possible.

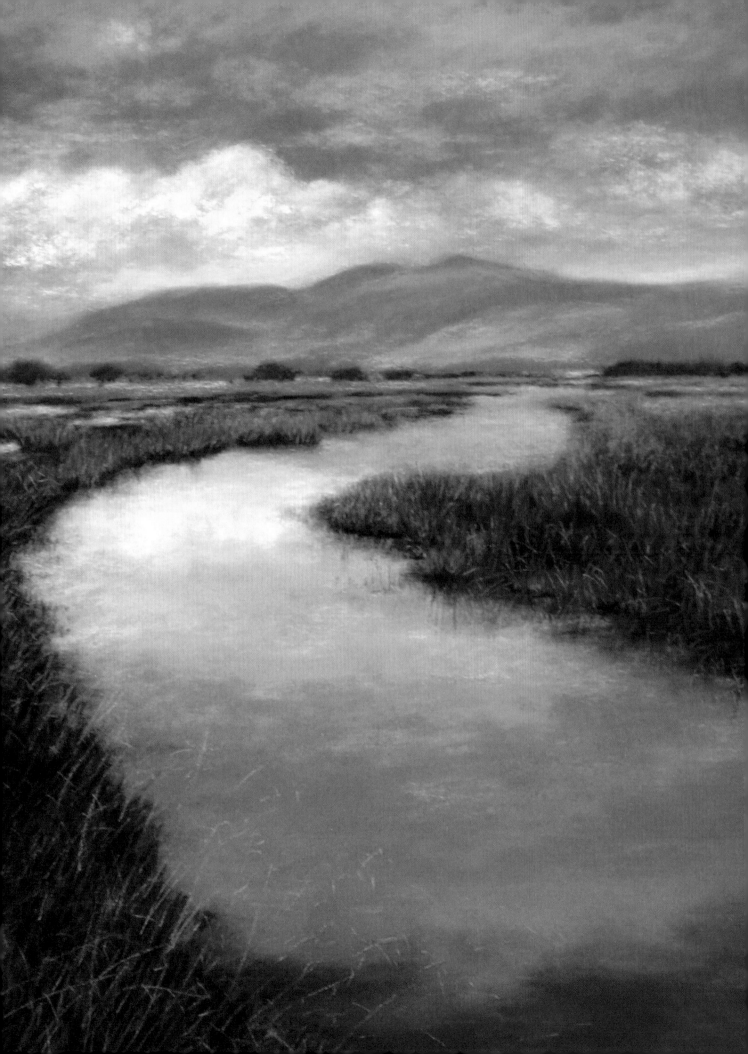

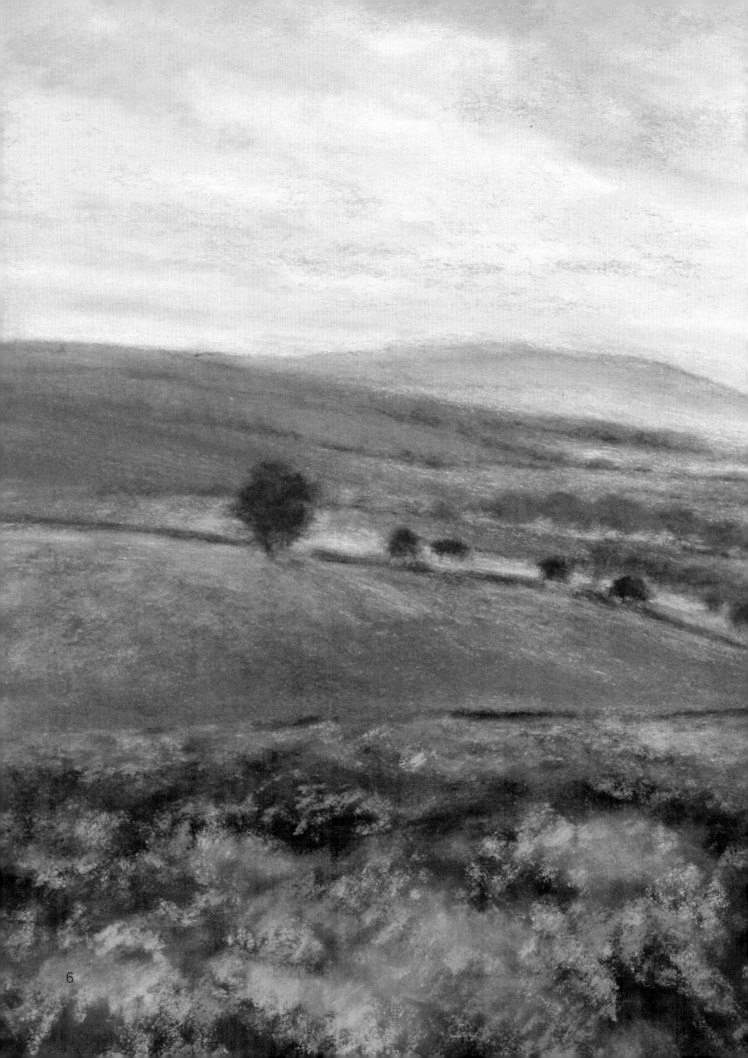

GETTING
Started

What is Pastel?

Pastels are made up of three primary ingredients:

PIGMENT is a finely ground color in powder form. It is the key ingredient used to color the paint. Pigments are ground from vegetable, mineral, animal, or synthetic origins.

FILLER is used to give more volume to pastels and to affect the color. More filler is added to reduce the intensity of the color.

BINDER is used in very small amounts to mold the pastel into sticks. Binder is typically made of either gum arabic or gum tragacanth.

PASTEL IS CONSIDERED BOTH A DRAWING AND A PAINTING MEDIUM, COMBINING THE BEST OF BOTH WORLDS.

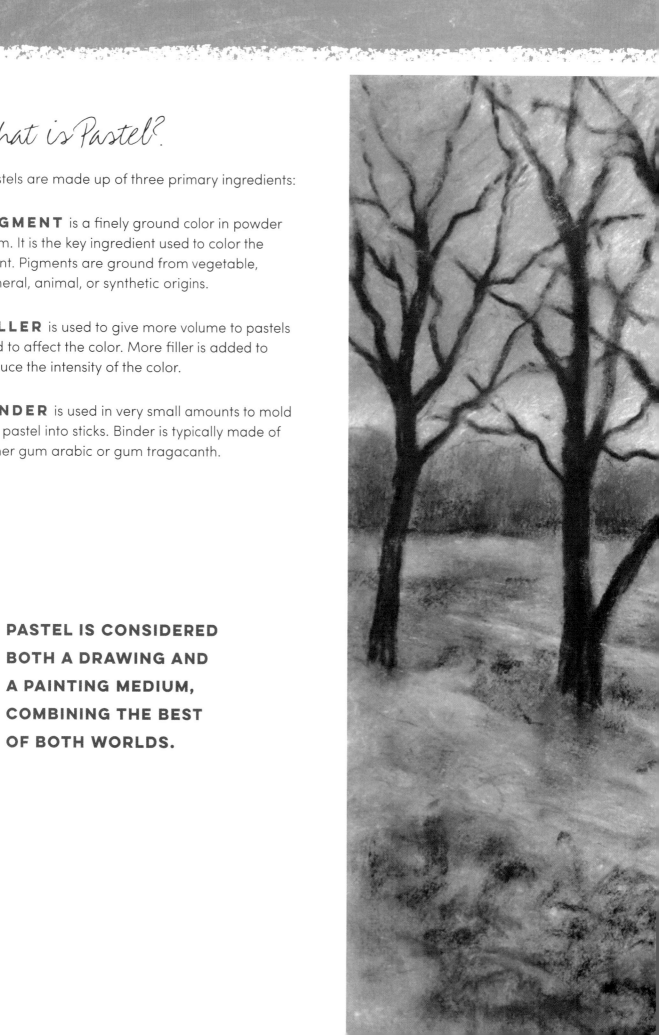

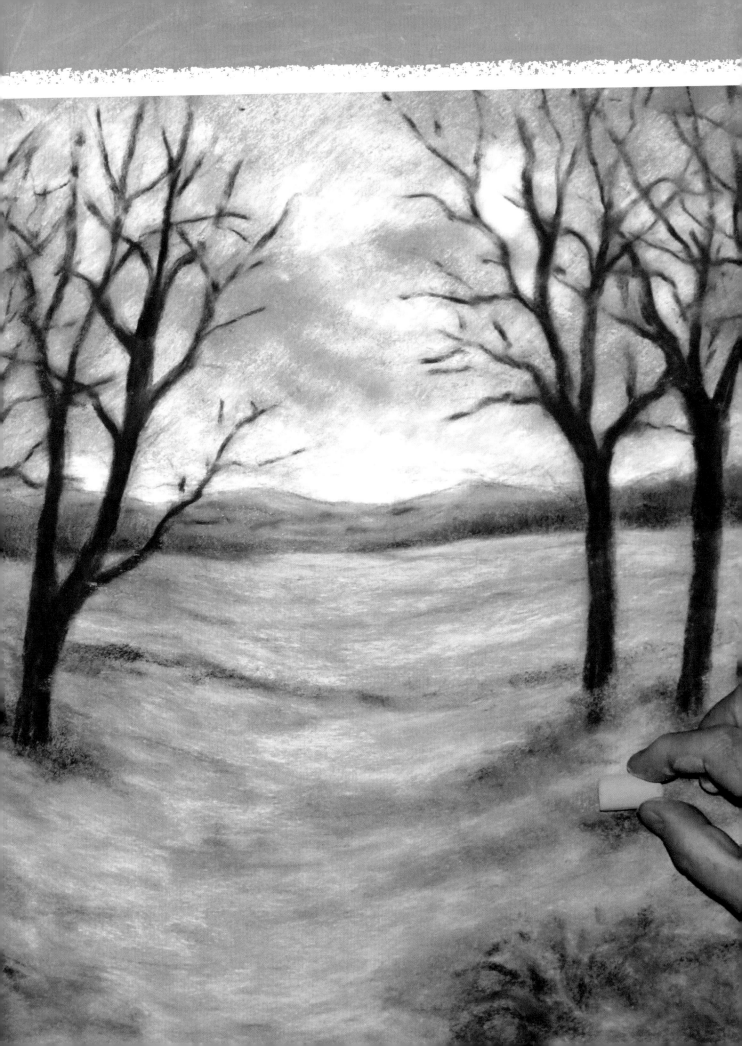

Tools & Materials

There has never been a better time to begin working with pastels! To many people, pastel is an exciting new medium that enables them to paint in different ways. If you are new to the medium, here are the materials I use and how they work for me.

SETTING UP

You should work upright when painting with pastels, with the surface taped to a board and attached to an easel. Ideally you should work from the top of the painting downward. However, if you don't want to stand, consider a tabletop easel.

SOFT PASTELS

There is a fantastic range of pastels to choose from. I work almost exclusively with half-stick soft pastels. The creamy consistency and vibrant colors of soft pastels mean that you can paint very quickly and intuitively—no color mixing is needed. A wide variety of brands, colors, and sizes is available.

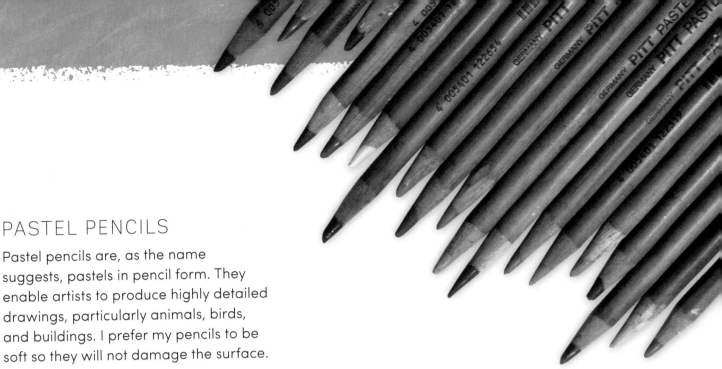

PASTEL PENCILS

Pastel pencils are, as the name suggests, pastels in pencil form. They enable artists to produce highly detailed drawings, particularly animals, birds, and buildings. I prefer my pencils to be soft so they will not damage the surface.

CHARCOAL STICKS

The charcoal sticks I use are made from natural willow and are specially designed for drawing. They produce a soft effect that is ideal for fine detail and creating shadows. Willow charcoal sticks are available in long lengths and different thicknesses.

BLENDING TOOLS

I prefer to use my fingertips for blending colors together, but if this is not for you, try wearing a surgical glove, or use a number of blending tools, such as blending stumps, watercolor brushes, and paper towels. You can even use cotton swabs!

KEEPING IT CLEAN

Keeping your painting clean is vital if you want to maintain its beautiful colors. Clean your hands at regular intervals as you apply pastel color to the surface. I use wet wipes to clean my hands, and then I thoroughly dry them with a cloth or paper towel.

SURFACES

I have tried many different surfaces, both paper and card, and now I paint primarily on a sanded card surface. Sanded card is available in many colors and grades. It can be purchased in sheets or pads of varying sizes. Try out a few different brands, colors, and grades before deciding which surface feels right for you.

tip

PASTEL IS A DRY MEDIUM, SO MAKE SURE TO WORK ON A SURFACE WITH AMPLE TOOTH (TEXTURE) TO ENABLE THE PASTEL TO ADHERE TO THE SURFACE.

OTHER OPTIONS FOR SURFACES

Rough drawing paper

Fine-toothed drawing paper

Sanded pastel paper

Cold-pressed paper

Laid drawing paper

Toned paper (with tooth)

Color Basics

Having a basic understanding of color will help you use it to express mood and create stimulating color effects.

UNDERSTANDING COLOR

The color wheel can be broken down into three categories: primary colors, secondary colors, and tertiary colors. The three primary colors are red, yellow, and blue. These cannot be created by mixing other colors, and all colors are created from the three primaries.

Combining two primary colors creates a secondary color. Secondary colors include orange, green, and purple. Tertiary colors are created by mixing a primary color with a secondary color. Tertiary colors include red-purple, red-orange, yellow-orange, yellow-green, blue-green, and blue-purple.

COLOR RELATIONSHIPS & VALUE

Extreme values of light and dark placed next to each other create a strong contrast, which attracts attention. Subtle value changes create soft transitions.

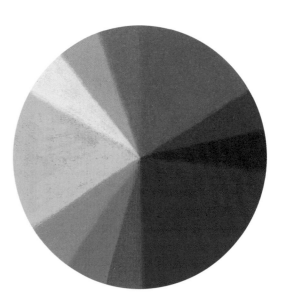

Value means the relative darkness or lightness of a color. Every color has a corresponding value, and the extremes of value are black and white. Black is added to pastels to create darker shades of color; white is added to create lighter tints; and gray is added to a color to mute it, creating a tone. You can purchase shades, tints, and tones, or mix your own by blending and layering.

Painting Techniques

My primary philosophy for working with pastels is to *keep it simple*. With that said, there are various techniques for pastel painting. You can paint almost anything by following these techniques.

HOLDING THE PASTEL

The simplest way to hold a pastel is between the thumb and forefinger. You should be comfortable with the way the pastel feels in your hand. Take your time to get used to the feel of the pastel.

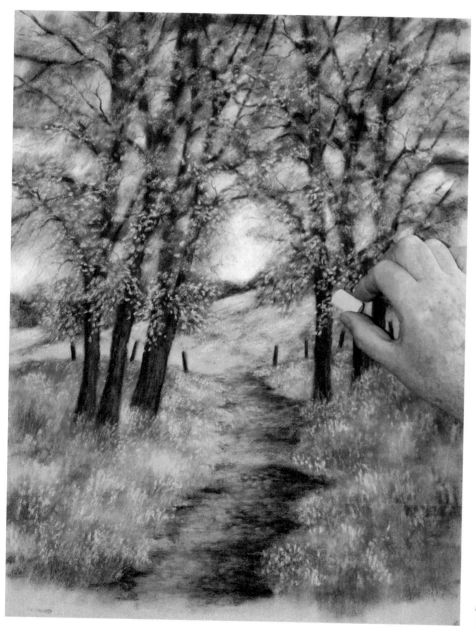

When painting with pastel, it often works best to use an upright surface.

3 BASIC TECHNIQUES

All of my paintings are created by using the pastel stick in just three ways. Once you master these techniques, you will be well on your way to producing your own works of art.

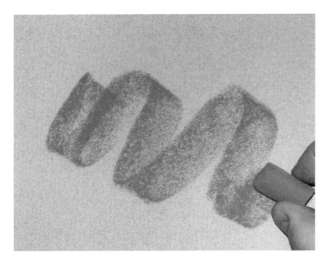

FLAT SIDE

Hold the pastel firmly, and place the flat side on the surface. Now move the color lightly from left to right to create broad swirls.

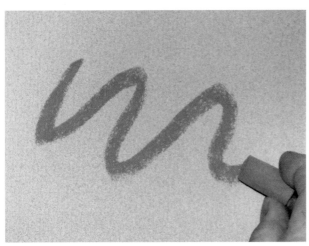

CHISEL EDGE

Create a chisel edge by running the top edge of the pastel across the surface. Place the chisel edge on the surface, and draw a thick, wavy line. Try to keep the color even through the length of the line.

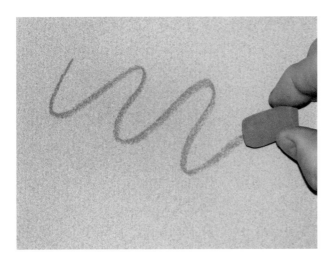

SHARP EDGE

To create a sharp edge, rub the end of the pastel on the surface and flatten it, giving a flat top to the pastel with a sharp edge all around. Use the sharp edge to draw a fine line across the surface.

10 Simple Exercises

The following 10 exercises will help you get more comfortable with holding a pastel and will give you an understanding of how a pastel performs. For each of the following exercises:

- Draw a simple rectangular shape.
- Try to keep the pastel marks within the boundaries of the shape.

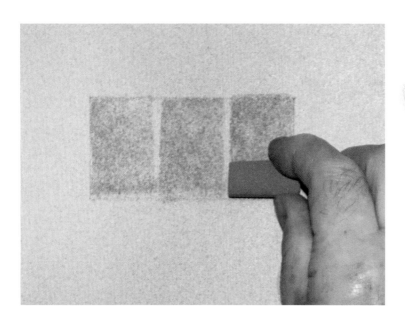

1. USING THE FLAT SIDE

Use the flat side of the pastel to create blocks of color within the rectangle. Try to place the color very lightly. This technique is useful for creating the underpainting and is often used for blocking in skies, the sides of buildings, and reflections in water.

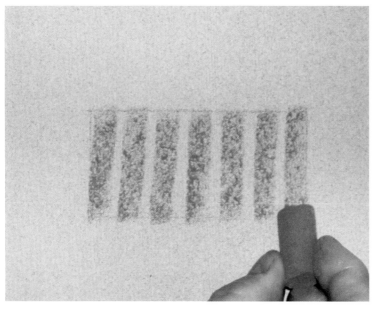

2. USING THE CHISEL EDGE

Create a chisel edge. Then draw a few vertical lines with this edge. The chisel edge is useful for creating thick strokes, such as tree trunks, foliage, gates, and fence posts.

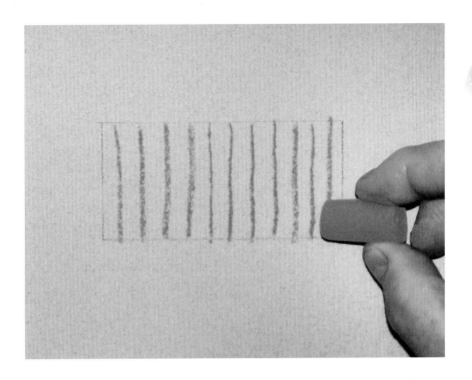

3. USING THE SHARP EDGE

Create a sharp edge, and then draw a series of vertical lines. The sharp edge is often used to add finer details to a painting, such as twigs and branches on trees, fine grasses, and small flowers.

VARYING THE PRESSURE TO CREATE DIFFERENT TONES OF COLOR

Now use a light touch, and work from left to right, increasing your pressure. Notice how a darker tone appears.

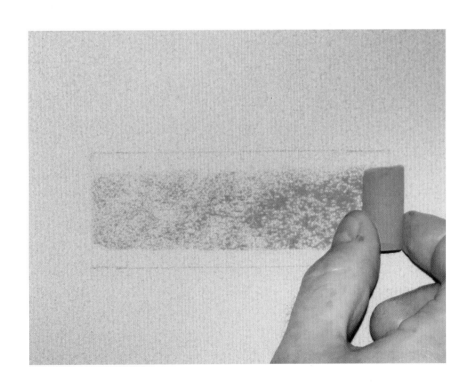

4. USING THE FLAT SIDE

Place the flat side of the pastel gently onto the surface. Start very lightly, and increase the pressure on the pastel as you move from left to right.

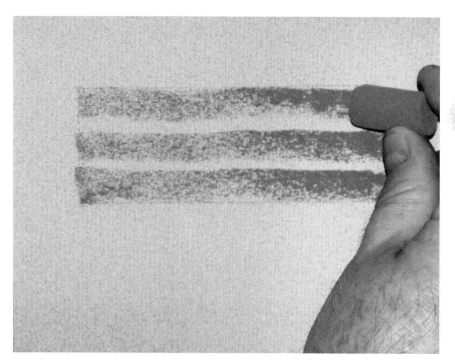

5. USING THE CHISEL EDGE

Place the chisel edge onto the card. Again, aim to vary the tone of the color by increasing the pressure on the pastel as you move from left to right.

6. USING THE SHARP EDGE

Now use the sharp edge, and increase the pressure on the pastel as you move from left to right. The line may become slightly thicker as you increase the pressure.

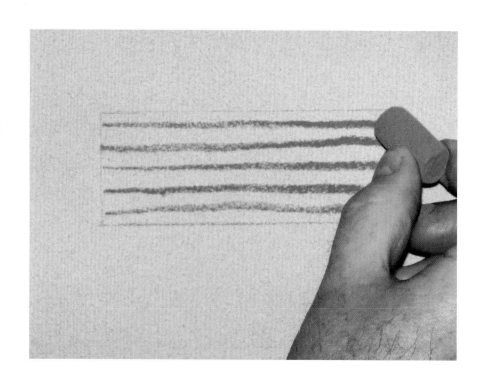

OVERLAYING COLORS, BLENDING & ADDING DETAIL

7. USING THE FLAT SIDE FOR BLENDING

Use the flat side of four shades of blue and white. Start with the darkest shade, and slightly overlap the colors.

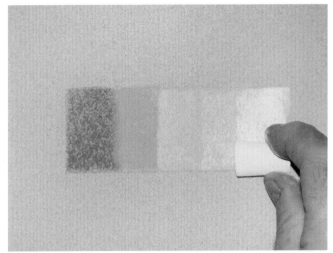

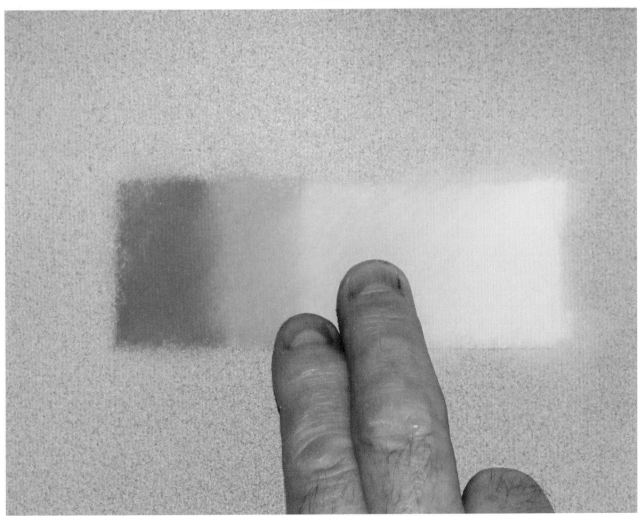

Now blend the colors from left to right using the tips of your fingers or a blending tool.

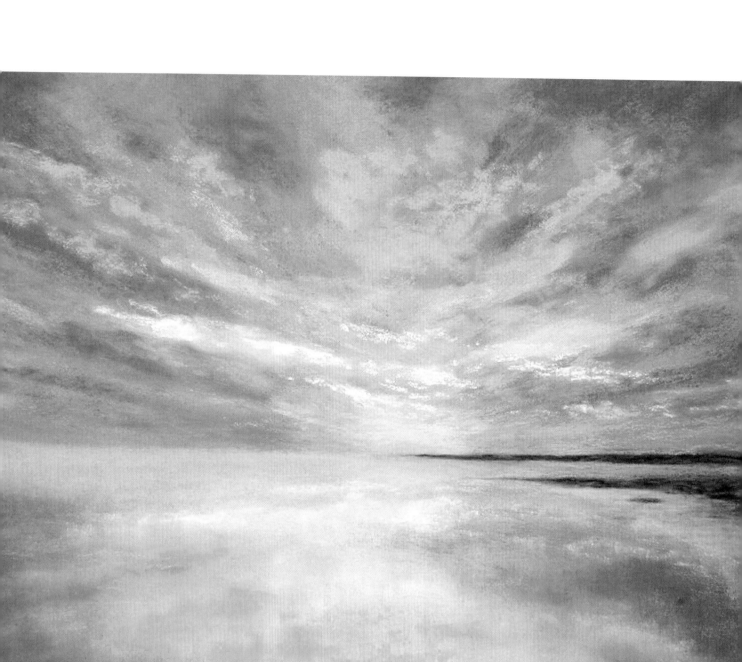

This painting was created almost entirely by overlaying colors using the flat side of pastels and carefully blending with fingers.

8. USING THE CHISEL EDGE FOR BLENDING

Select three shades of green from dark to light. Starting with the darkest, use the chisel edges of the pastels to overlap vertical shapes onto the surface. Blend the colors together with an upward motion.

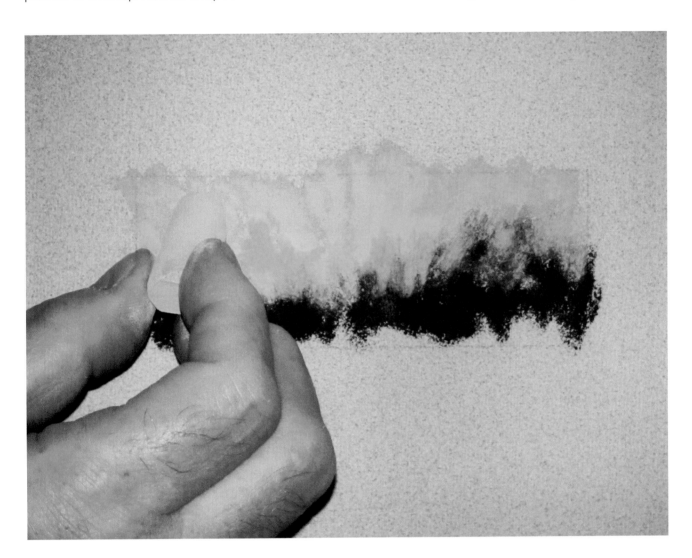

This technique is perfect for creating an underpainting for detailed grasses and flowers.

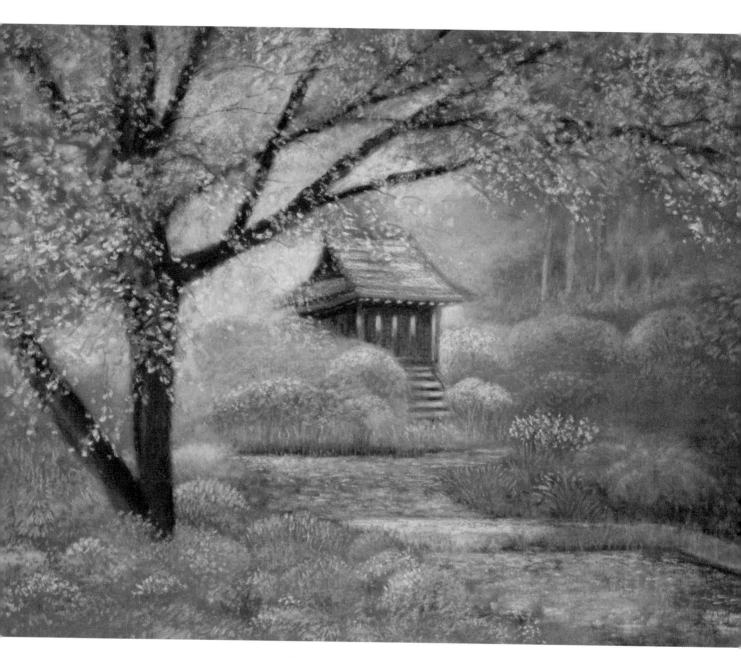

Notice the chisel edge technique used in this painting, particularly in the tree, building, and water.

9. USING THE SHARP EDGE TO ADD DETAIL

Use the sharp edge of the pastel to make diagonal scribble strokes from left to right. Overlay different colors to represent grasses.

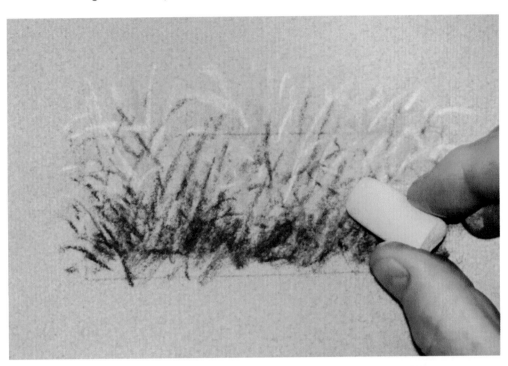

Repeat these strokes to create an underpainting. Then use the sharp edge to scribble grass on top of the underpainting.

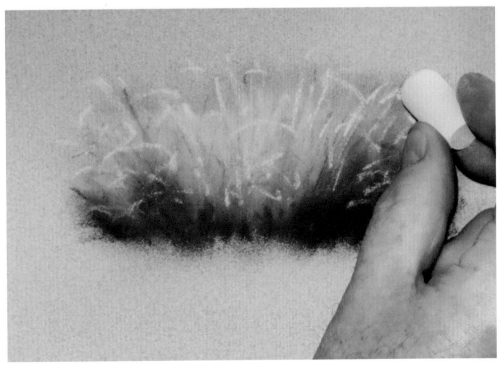

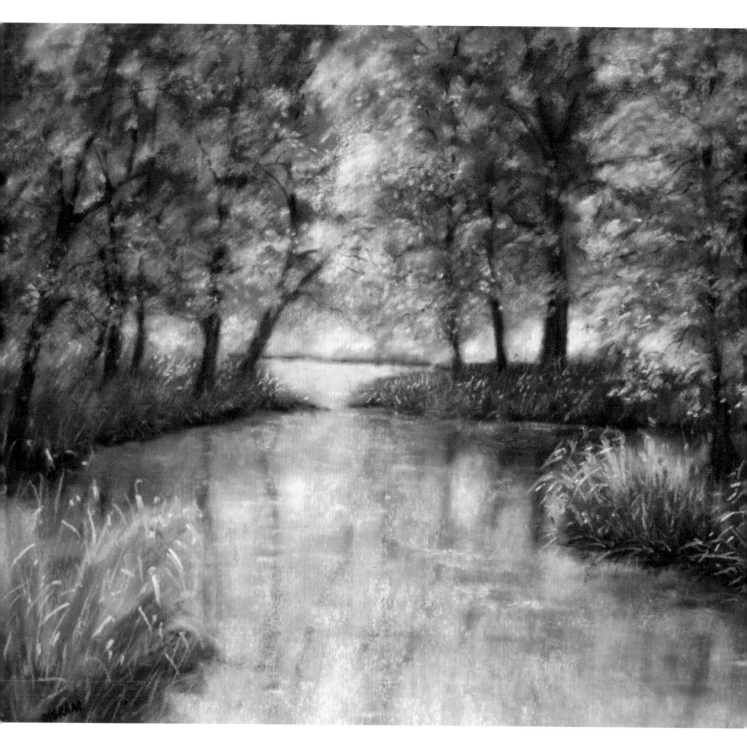

This painting shows how effective the sharp edge of the pastel is for creating fine grasses around a small lake.

24

10. BRINGING IT ALL TOGETHER

This exercise incorporates all of these techniques into one simple painting. The subject is a single oak tree on a grassy hill on a bright summer's day. Use the following pastel colors: dark blue, mid-blue, and pale blue; dark green, mid-green, and pale green; bright yellow; dark brown; and a charcoal stick.

Draw the tree shape, the hill, and the fence posts in charcoal or soft pastel pencil onto a sanded card. Use the flat side of all of the pastel colors to block in the painting.

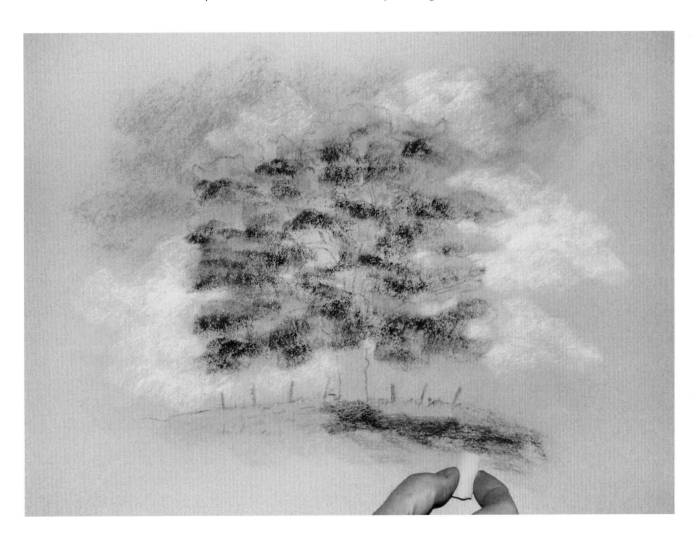

Using the chisel edge of the dark brown pastel, create the tree trunk and the branches. Add a shadow underneath the tree. Blend carefully.

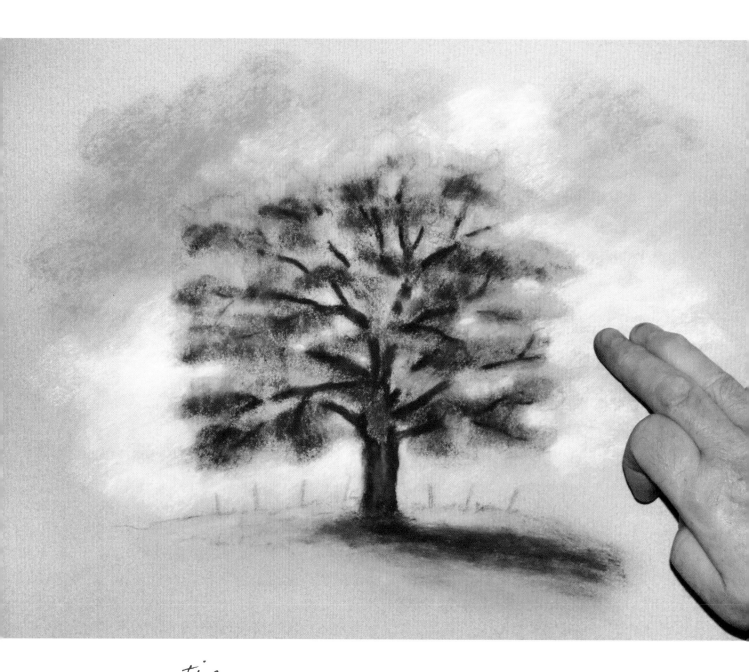

tip

BLENDING CREATES THE UNDERPAINTING AND SETS THE COLORS.

Using the sharp edge of the dark brown pastel, draw the fence posts. Use the sharp edge of the bright yellow pastel to add leaves to the tree and highlight the grasses to show sunlight hitting the grass on the hill. With a charcoal stick, add fine branches and wire to the fence posts, and soften the shadow under the tree.

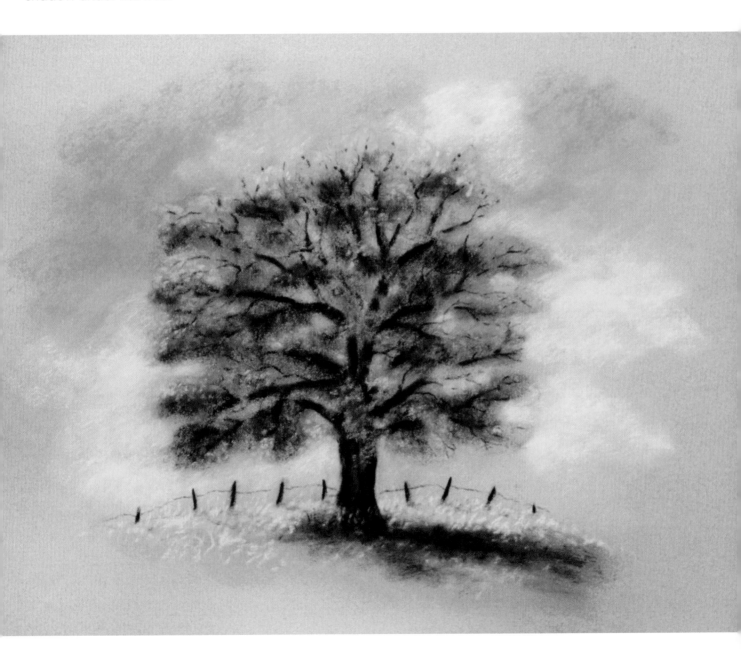

Painting with Pastel

Once you understand how to build up the fine layers of color, you are on your way toward producing great pastel paintings. Here is a simple formula for painting with pastel:

1. Choosing the right colors
2. Sketching the subject
3. Underpainting
4. Adding depth and color
5. Adding detail

1. CHOOSING THE RIGHT COLORS

This can be the biggest challenge for anyone new to the art of pastel. Try beginning with a preselected landscape box produced by pastel manufacturers, or develop your own unique range of colors.

Over the next few pages, follow along as I use my painting called "Autumn Reflections" to show you my process for successful pastel painting. These are the sixteen colors used in this painting: deep red, rust red, dark brown, mid-brown, golden yellow, mid-yellow, pale yellow, cream, dark blue-green, mid-green, pale green, light blue, deep purple, dark gray, mid-gray, and white.

tip

YOU CAN TEST THE COLORS BY STROKING EACH PASTEL ONTO A SMALL STRIP OF SANDED CARD. THIS HELPS YOU SEE THE ACTUAL COLOR BEFORE YOU BEGIN PAINTING.

2. SKETCHING THE SUBJECT

When sketching out the subject, use a soft black pastel pencil or charcoal stick. Then gently rub your fingers over the drawing to wipe away any excess black pastel dust. This will keep your painting clean as you add more colors.

Sketch lightly on the surface, without including much detail.

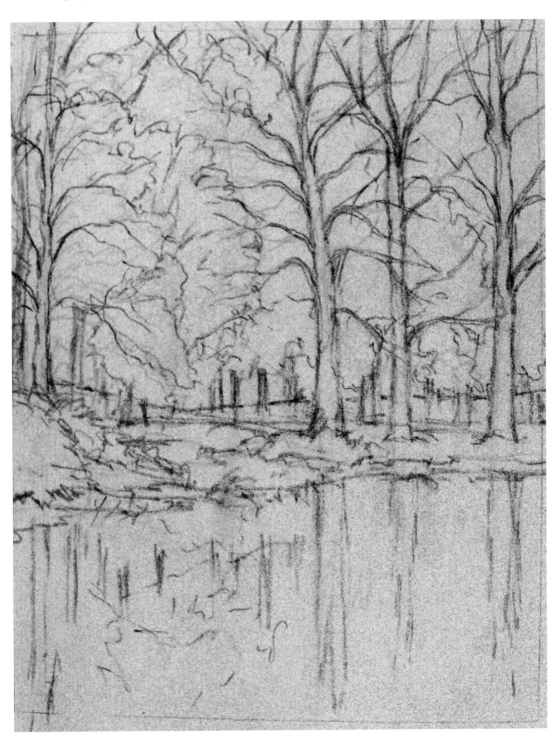

3. UNDERPAINTING

The underpainting is the first layer of color placed on the surface. It gives a solid foundation for the next layers of pastel and sets the mood for your painting. The best way to create an underpainting is to block in the colors with the flat side of your pastel using broad strokes.

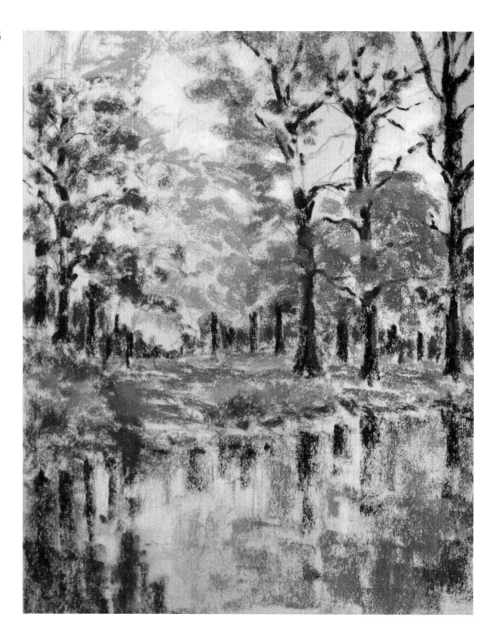

tip

APPLY PASTELS AS LIGHTLY AS POSSIBLE. TRY TO LEAVE SOME OF THE BACKGROUND SURFACE SHOWING THROUGH.

4. ADDING DEPTH & COLOR

Blend the colors carefully with your fingers or a blending tool to "fix" them onto the surface. Then add layers of pastel to create depth and color. Working from dark to light intensifies the colors and enables you to bring areas of bright light to your subject. Further blending is sometimes needed to add more depth and additional layers of color.

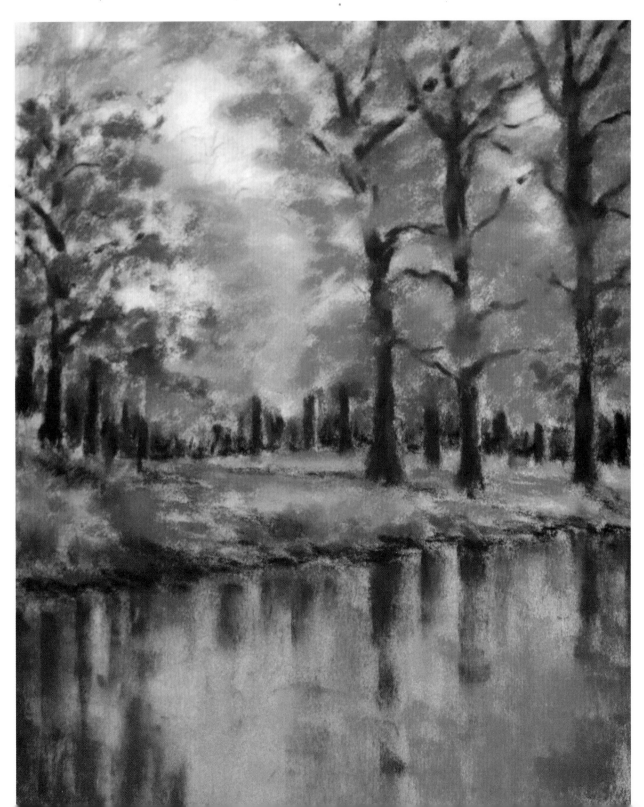

5. ADDING DETAIL

This is the last stage in the process. When using sanded card, there should still be enough "tooth" left to add some finer details. Add details using a combination of the sharp edge of the pastels and soft pastel pencils. Always try to work away from your painting, without resting your hand or wrist on the surface.

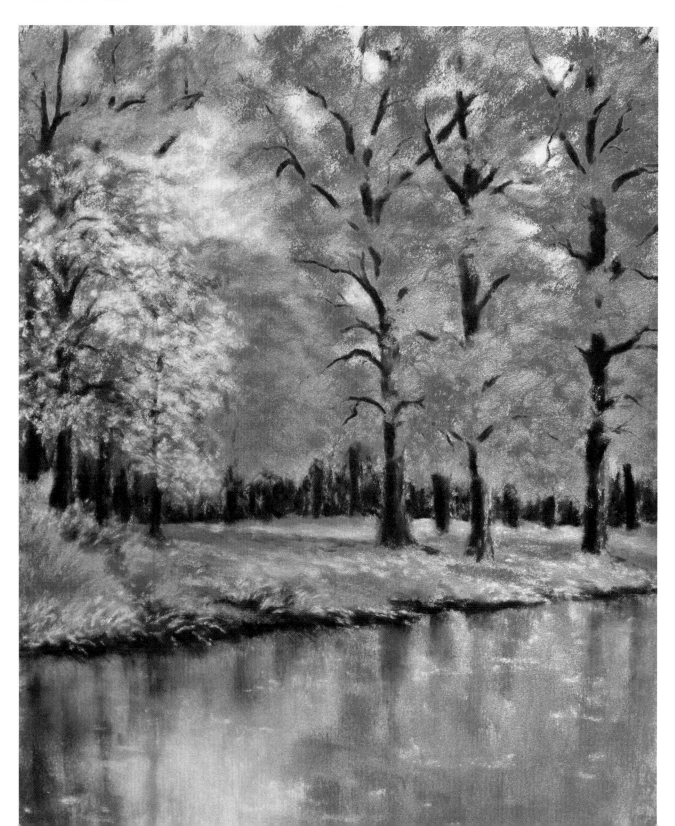

Protecting Your Painting

Pastel is one of the most delicate art mediums available to artists today. The raw pigment used in the pure color particles catches and reflects the light, making pastel unique. However, great care needs to be taken when handling your finished painting.

I never "fix" my paintings with sprays, because I believe they can damage the quality of the pure color particles contained within the pastel pigment, making a painting appear dull and lifeless. Some artists use fixative sprays in the early stages of a painting and leave the final layer of pastel pure and unfixed.

I work on a sanded card surface, which helps to fix the pastel to the surface. When I have finished a painting, I gently tap the edges and back of the painting to dislodge any loose pastel dust before storing or framing.

COVER & STORAGE

Do not allow anything to touch, rub, or scrape the delicate surface of your pastel paintings. Safely storing your finished paintings can be a little tricky. Here is one way to protect them.

YOU WILL NEED

3 sheets of foam board

1 sheet of greaseproof or waxed paper

Adhesive tape

Tape your finished painting to a sheet of foam board that is larger than your painting. Then cut a mount area out of the second piece of foam board, and place it over your painting. Secure all four sides with tape. Cut a sheet of greaseproof paper that is slightly larger than the painting, and cover the picture by taping directly over the top of the foam board mount. This protects the pastel surface from damage. Then take the last piece of foam board, and trim it to the same size as the first one. Place it very carefully over the top of your painting. Tape all four sides together to create a secure "sandwich" for your painting.

MOUNTING & FRAMING

When it comes to framing your painting, the best course of action is to take it to a professional framer with experience in framing pastel artwork.

Choosing a Subject

One of the main dilemmas facing an artist is choosing a subject to paint. I am primarily a landscape painter, and it is my belief that you should only paint something that interests and inspires you. I have been asked to paint animals and people, but my heart lies in trying to capture the beauty of an ever-changing landscape.

REFERENCE PHOTOS

Although I do paint outside (*en plein air*), I also paint from photographs. I like to take many photographs in one session, download them to my laptop, and crop them to my perfect composition.

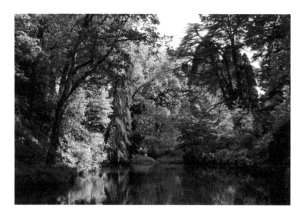

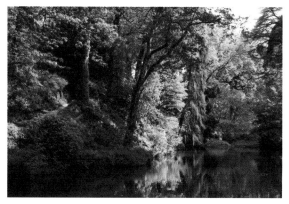

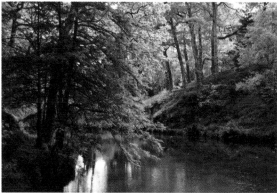

The three photographs above were taken in late summer at Bodnant Garden, in North Wales.

Out of these three, I eventually chose the third composition to paint. The photograph lacks light, but I thought that it captured the subject perfectly.

In the finished painting "Toward the Far End," you will notice that I increased the light around the trees on the right and extended the river between the group of trees on the left. I also added some color in the river.

34

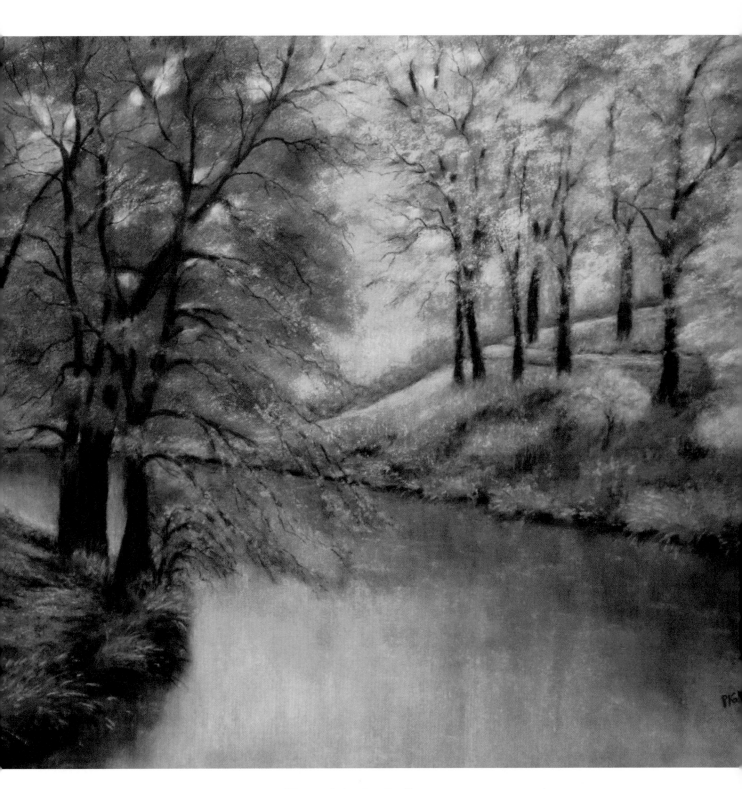

"Toward the Far End"

PANORAMIC SUBJECTS

While on vacation on Lindisfarne, an island off the coast of England, I woke up very early one morning with a deep red light coming through the window. The most amazing sunrise was about to unfold! I grabbed my camera and ran down to the water. I managed to take quite a few shots before the brilliant reds and purples disappeared, leaving a beautiful sunny morning. As luck would have it, I had taken a series of shots that were perfect for creating a panoramic view of the scene.

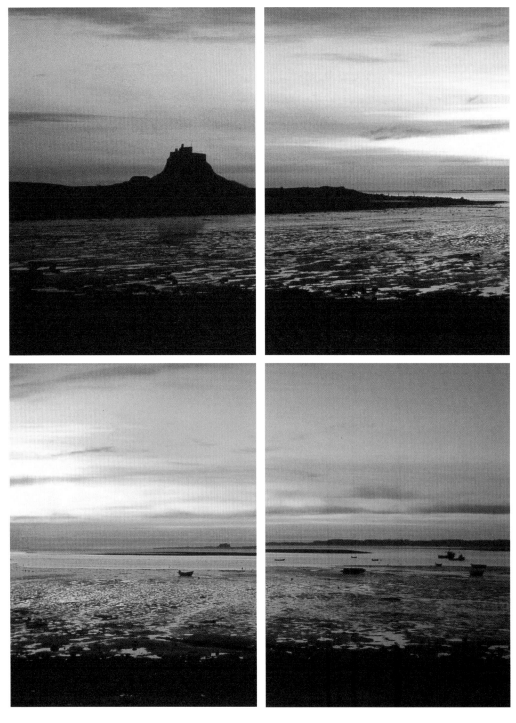

I merged these four separate photographs to create a fantastic panoramic view featuring a stunning sunrise.

PANORAMIC PAINTINGS SHOW A WIDE VIEW OF A SUBJECT, SUCH AS A LANDSCAPE.

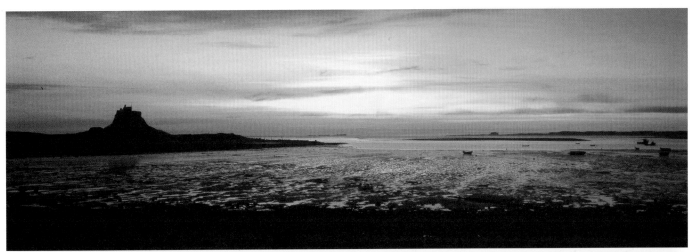

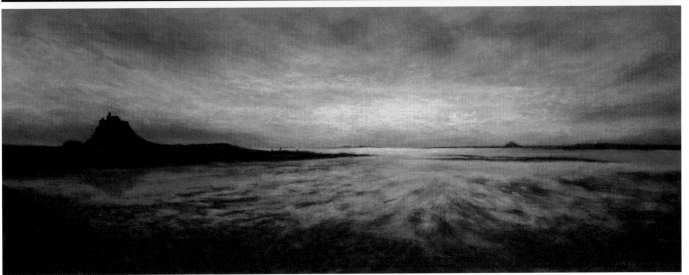

"Early Morning Sunrise on Lindisfarne"

Composition

Composition is simply about deciding where to place the main focus of your painting. There are various theories on this, such as the rule of thirds. However, I tend to look at a view or image and choose the composition that looks both balanced and interesting to my eye. Trust your instincts when choosing your own composition, but remember that most people look from left to right.

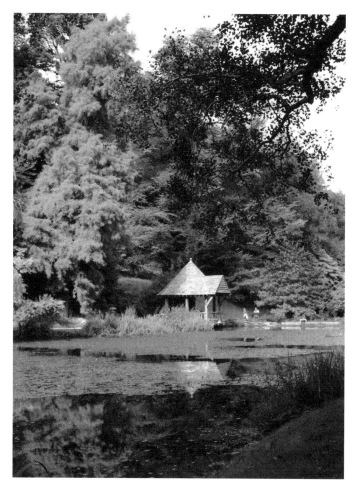

Portrait

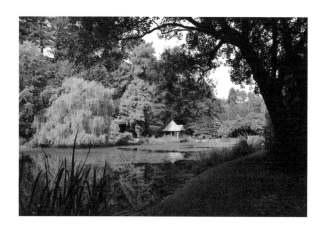

Landscape

These examples show how you can create three alternative compositions from the same photograph. The first photograph is the original landscape shot. The second photograph shows the same view cropped to show a portrait version. Finally, the third example shows how the composition looks when we focus on the boathouse in the center of the picture. Which one would you choose to paint?

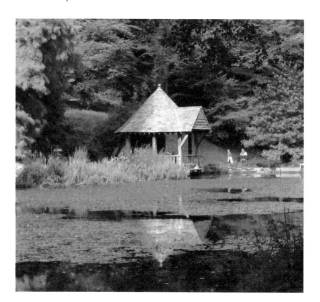

Close-up

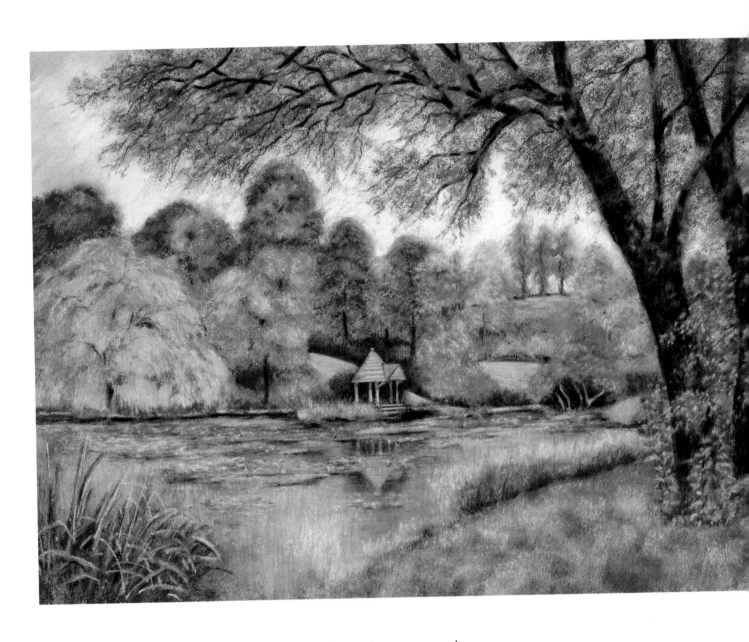

ACCORDING TO *the rule of thirds*, IF YOU DIVIDE A COMPOSITION INTO THIRDS, BOTH VERTICALLY AND HORIZONTALLY, AND PLACE THE KEY ELEMENTS IN THE IMAGE ALONG THESE LINES OR WHERE THEY MEET, IT MAKES FOR A BETTER COMPOSITION.

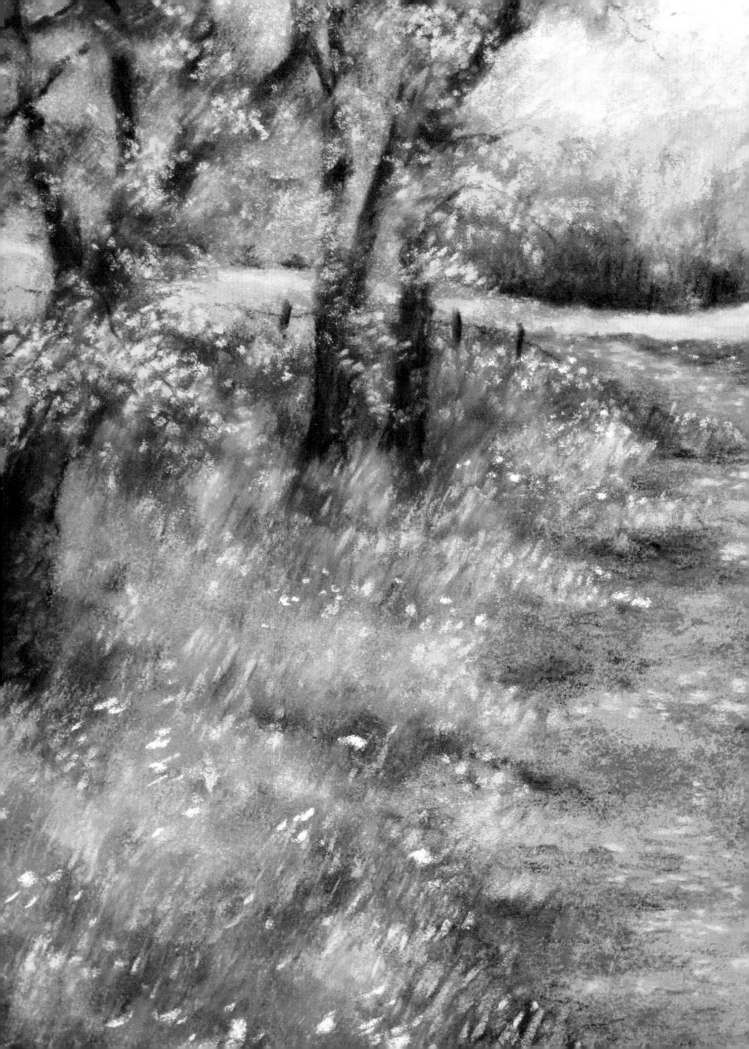

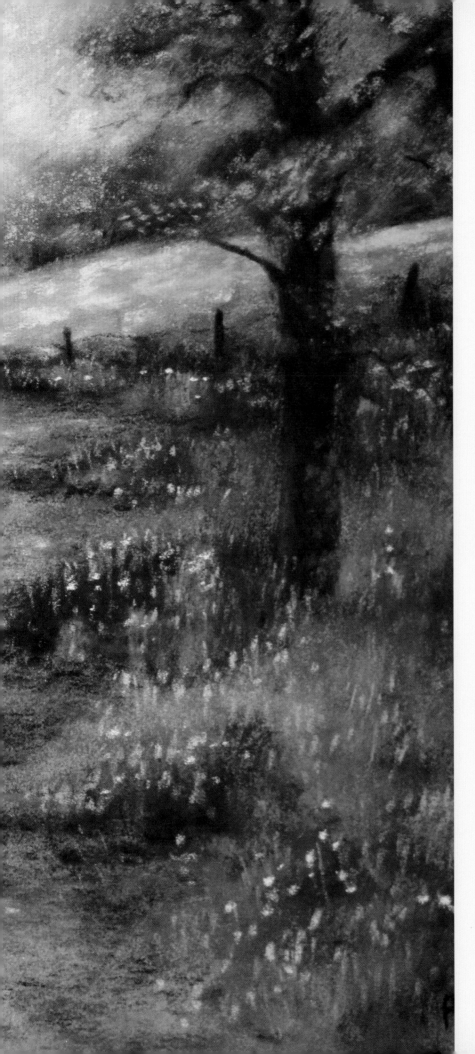

Choosing a Color Palette for Each Season

Choosing your colors is just as important as choosing your subject. The changing seasons bring constantly changing light, and this has a profound effect on the color palette that you will choose.

Take a look at the paintings featured over the following pages. Each features a subject and colors typical of each of the four seasons. When it's time to create your own pastel paintings, keep these color suggestions in mind.

SPRING

Spring comes alive after winter, bringing warmer days, new growth, and fresh colors like blues, greens, and yellows.

NOTICE PALE BLUE SKIES AND PALE SHADOWS.

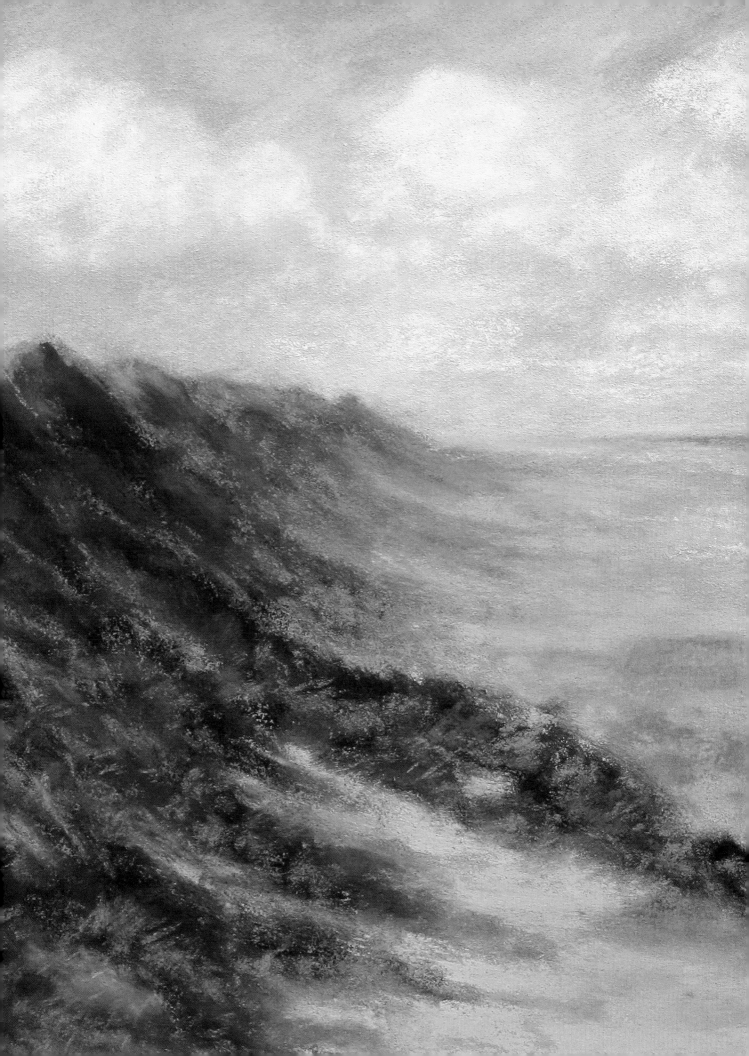

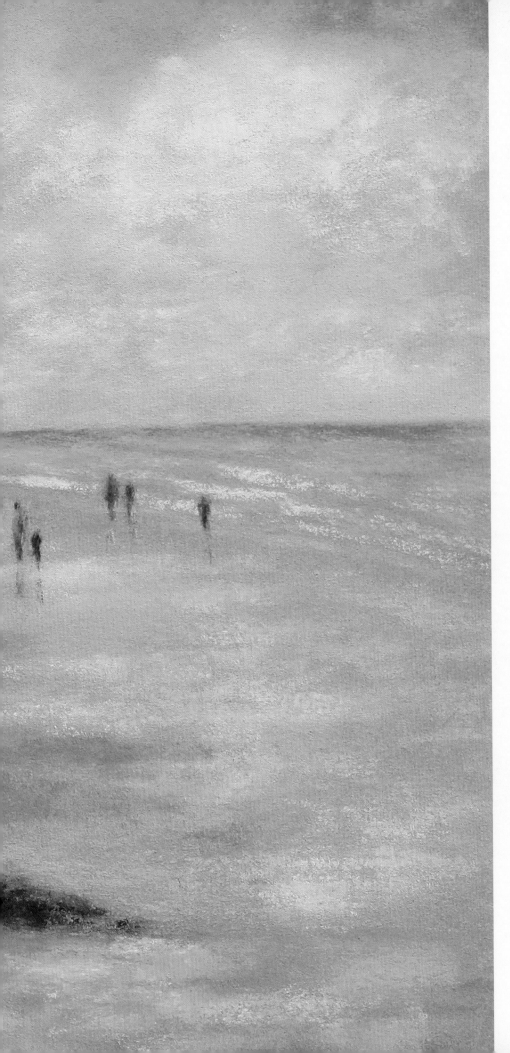

SUMMER

Summer brings hotter days filled with brighter colors, lush growth, and long, dark shadows.

FEATURE DEEP BLUE SKIES, WHITE CLOUDS, AND BRIGHT REDS AND GREENS.

FALL

In the fall, grass and flowers stop growing and the leaves fall. The colors are glorious, with warm reds, golden yellows, fading greens, and pink and purple skies.

CREATE PALER SHADOWS.

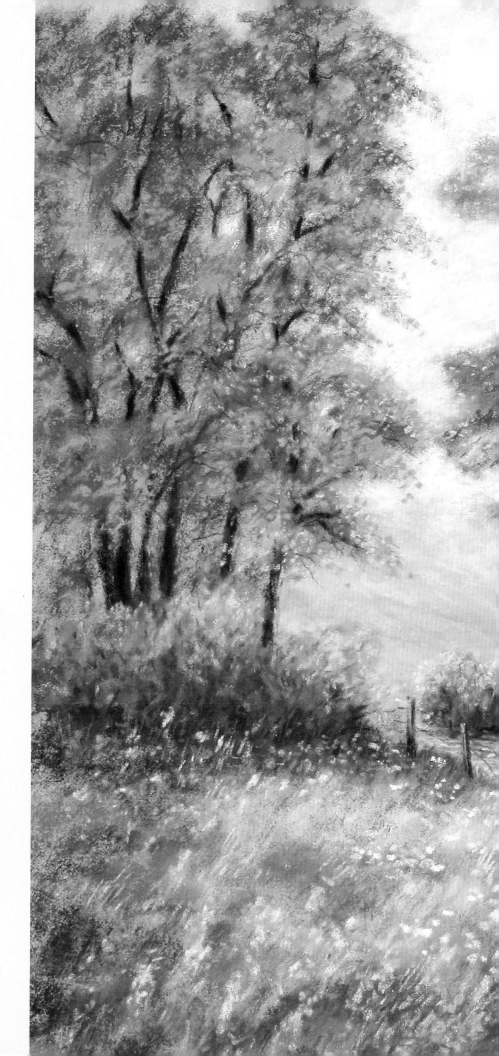

44

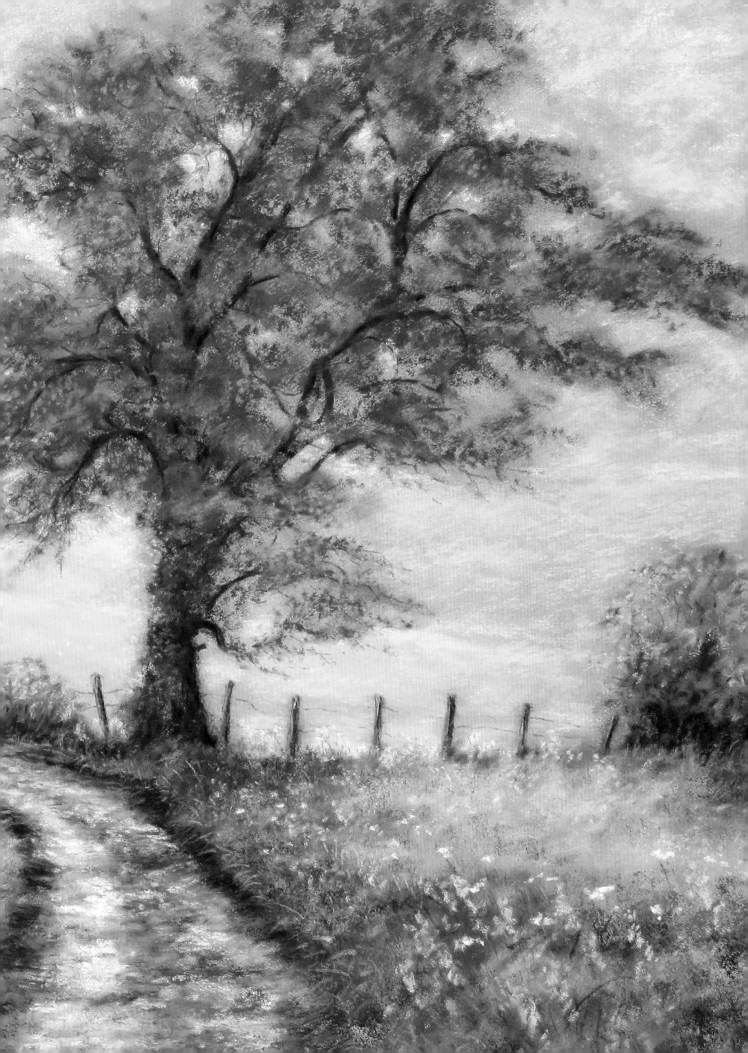

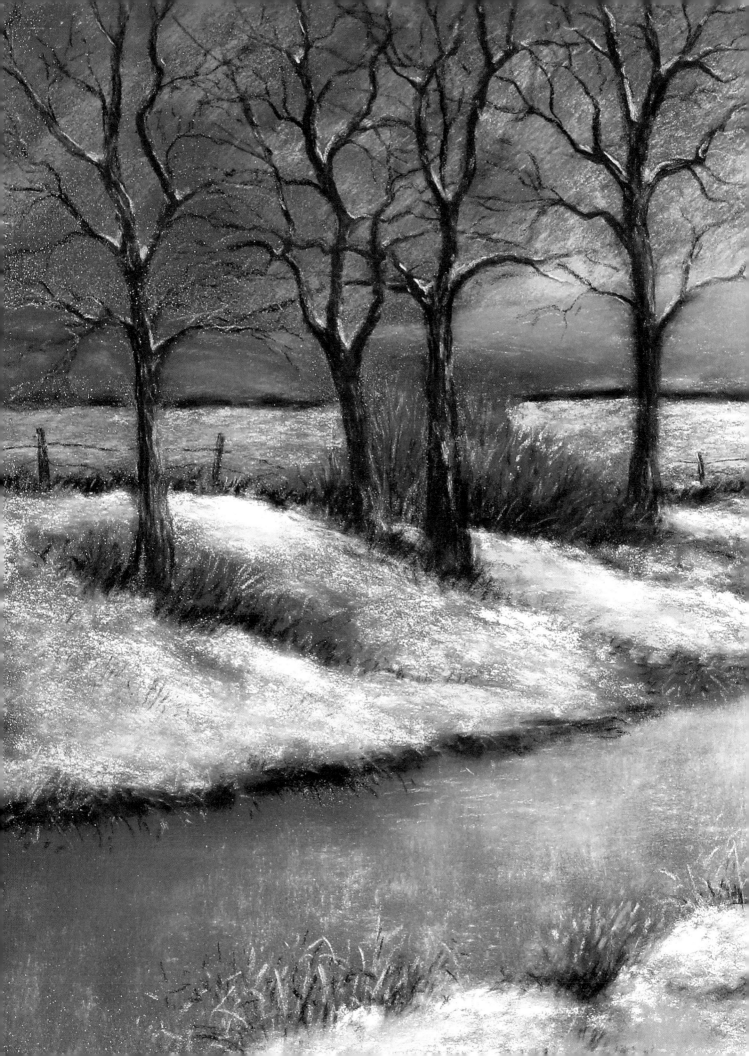

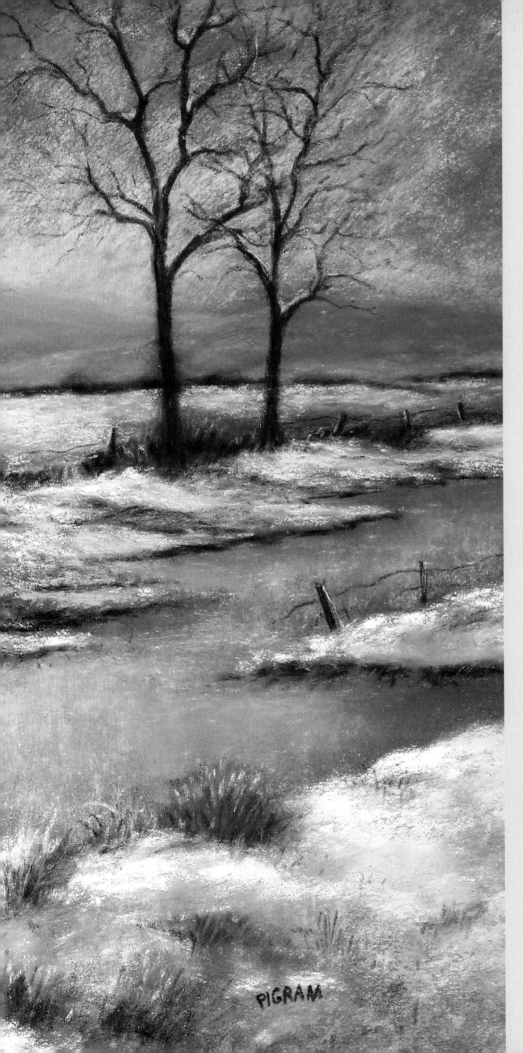

WINTER

Winter brings cold days and dark silhouettes. White snow features blue, purple, and light gray shadows.

PAINT PALE BLUES AND GRAYS, REDDISH BROWNS, DULL GREENS, AND PINK AND YELLOW SKIES.

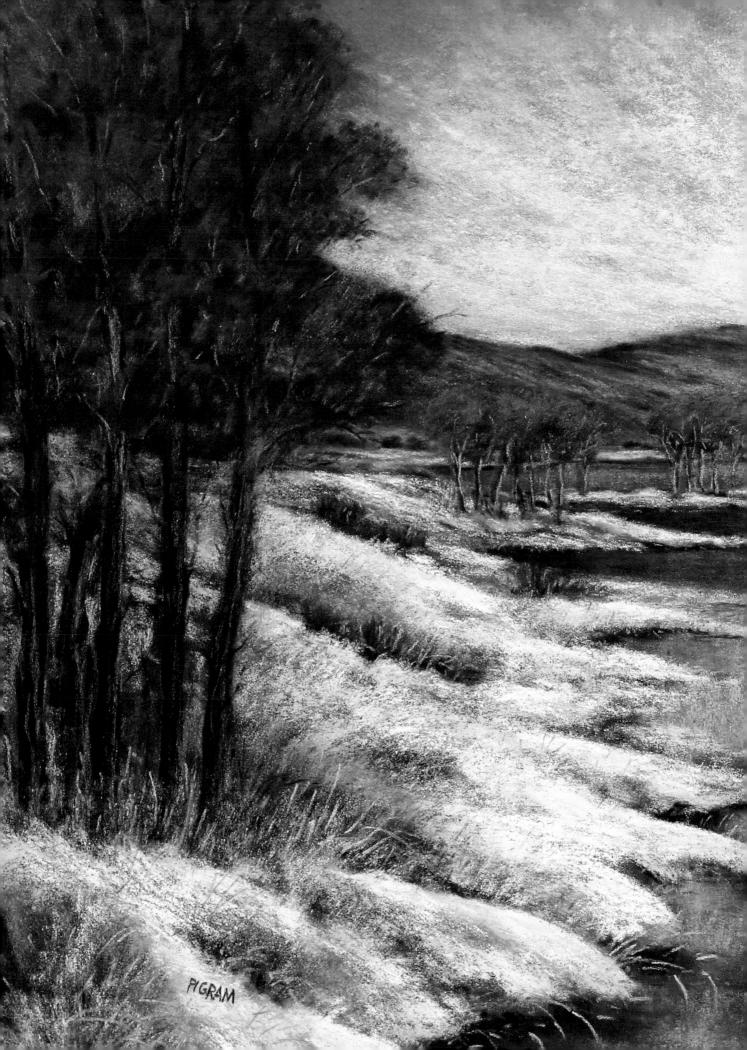

THE ELEMENTS THAT MAKE UP A
Painting

Trees

When painting trees, you will never run out of inspiration, whatever the season. Trees are constantly changing both in color and shape. Autumn is a wonderful time of year to paint trees, as the colors are absolutely staggering. Capturing the intense colors in autumn can be quite a challenge for any artist, but pastels are easy to blend, fluid, and forgiving, making them an ideal medium for painting trees in fall colors.

Sketching out the scene very loosely with a pastel pencil, start by outlining the shape of the trees. In this case, the central point of the picture is the end of the path. Note that the grasses on the left are taller than the ones in the middle distance. This helps keep the perspective.

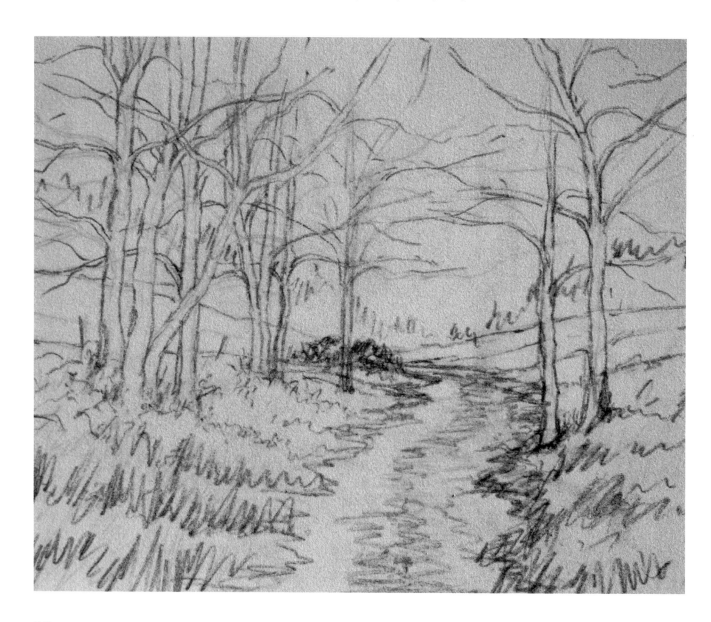

Using the chisel edge of a pastel, work in the shapes of the trees and a few main branches. Block in the sky, and include a small area of white to indicate sunlight coming through the clouds. You can use purple for the distant trees, with a light covering of pale green on the fields. Placing bright yellow and green on the trees in the center of the composition reflects the highlights coming from the sun. Block in the path, and scribble the grasses with dull shades of green, yellow, and brown.

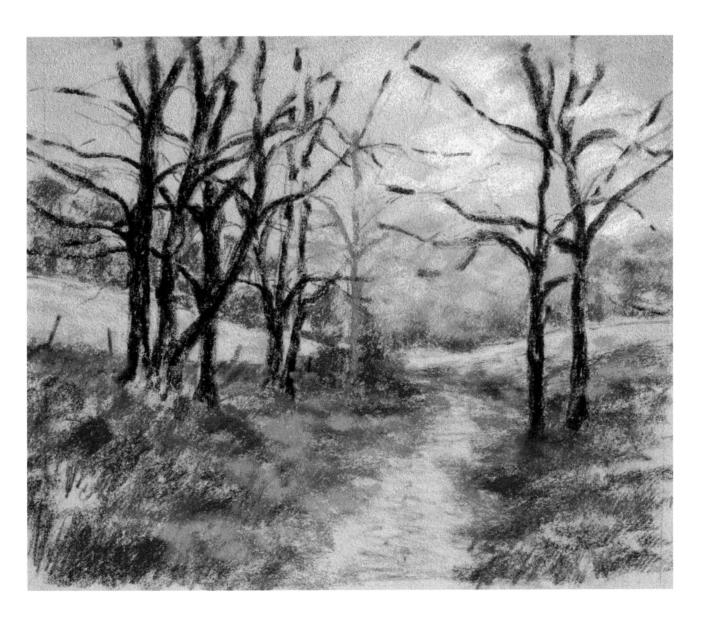

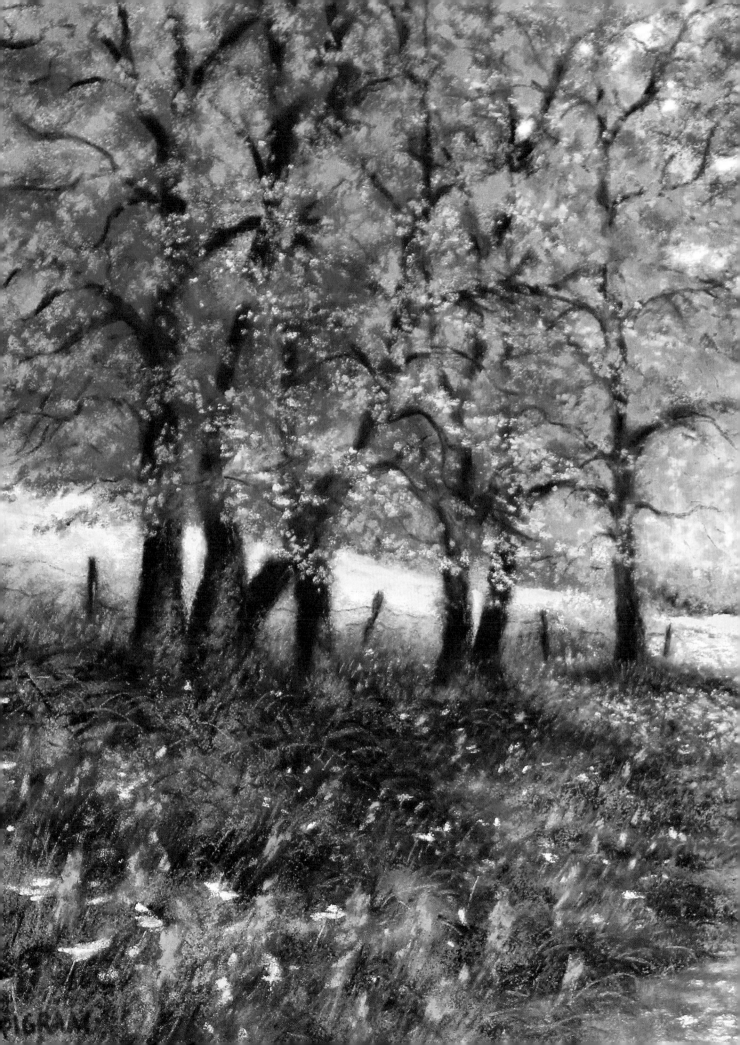

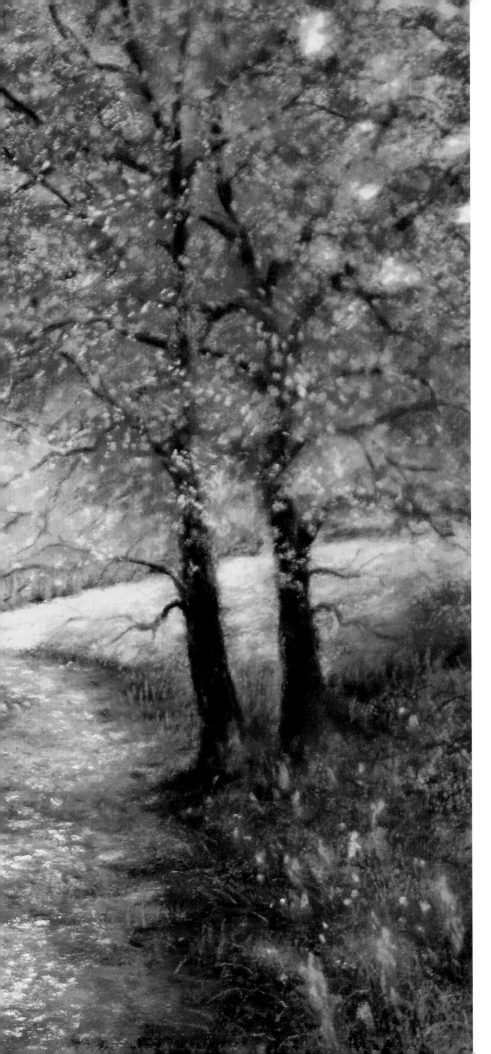

Block in shades of brown, red, yellow, and green into the trees. Increase the oranges and yellows at the end of the path, and add bright green to reflect the sunlight coming from behind the trees. Create wildflowers and grasses in the foreground with the edge of the pastel, and indicate fallen yellow-orange leaves. Blend the colors using your fingers or a blending tool.

Now create finer detail using the sharp edge of your pastels and a wide selection of pastel pencils. Add details to the wildflowers and grasses to create more interest in the foreground.

LEAD THE EYE DOWN THE PATH TOWARD THE BRIGHT YELLOW TREES AND FIELDS GLOWING IN THE AUTUMN SUNSHINE.

53

Mountains

Mountains stand proud on the landscape, but capturing this majesty has long eluded artists. This painting is inspired by Snowdon, the highest mountain in Wales. The rock is dark blue-gray, but when snow covers the peak, it looks stunning!

An accurate drawing is vital when painting mountains. Then block in the sky in shades of blue using the flat side of the pastel and working from dark to light. Use a very pale blue for the clouds.

Block in most of the mountain with shades of dark blue and brown. Begin to highlight some areas of snow to indicate that the sun shines from the top left of the picture.

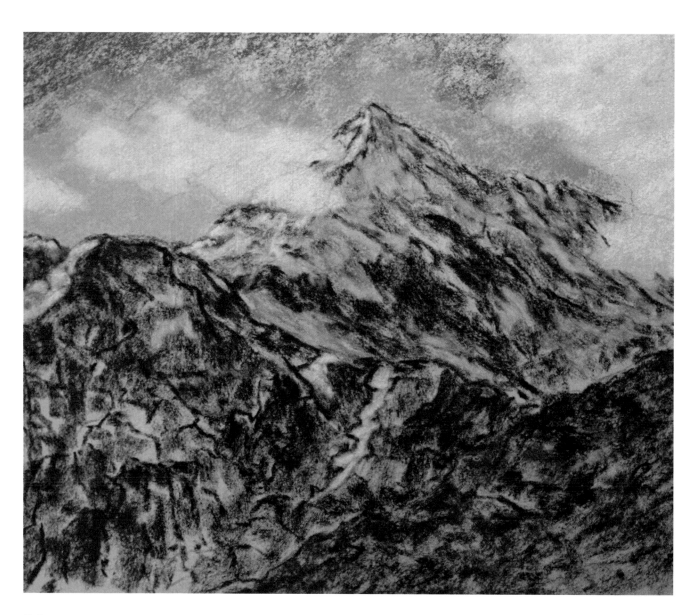

Start to add more colors to the sky, the mountainside, and the ground. Blend the colors using your fingers, remembering to rub lightly in the direction of the shapes within the mountain.

Any corrections need to be made before adding more color and finer details.

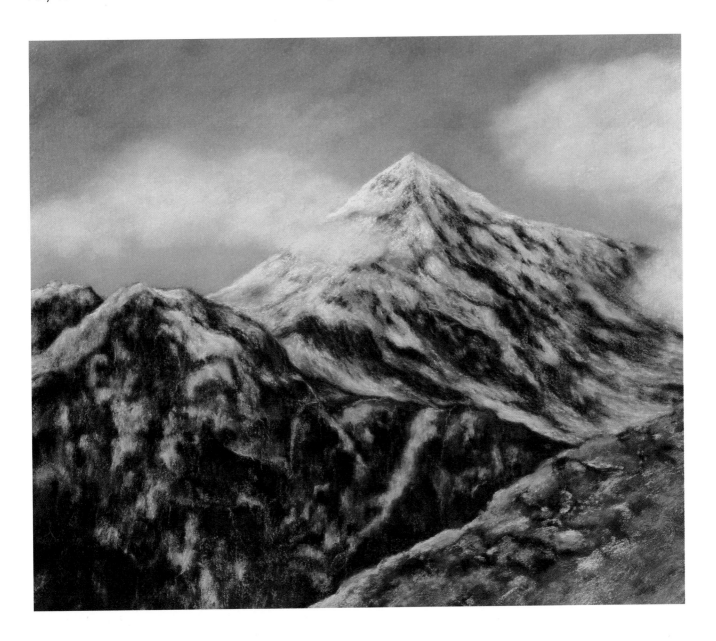

The final stage of painting a mountain involves increasing both the color and the detail across the whole painting. Add various shades of green and yellow into the foreground. Add brighter blues to the sky, and blend the clouds to complete this dramatic painting.

Water

Water brings joy and happiness, especially when the weather surrounding it is pleasant. Notice the mesmerizing reflections. Use these tips to create your own painting of a body of water.

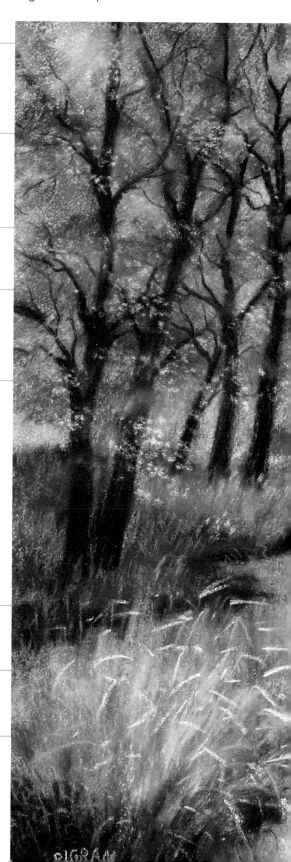

For the first application of color, focus on blocking in the key areas of the scene, such as the light source and reflections in the water.

Blend the colors with the tip of your finger.

Use the chisel edge of a pastel to draw the main elements in the painting and their shadows.

Create details, such as branches, with a charcoal stick.

Use the side of a pastel to create grass.

tip

KEEPING THE INITIAL DRAWING LOOSE USING JUST A CHARCOAL PENCIL HELPS THE SUBJECT RETAIN A SENSE OF FREEDOM.

Use a range of light green and pale blue pastels to highlight reflections in the water.

The grass in the foreground draws the eye into the painting.

Complete the painting with the edge of a pastel and various pastel pencils.

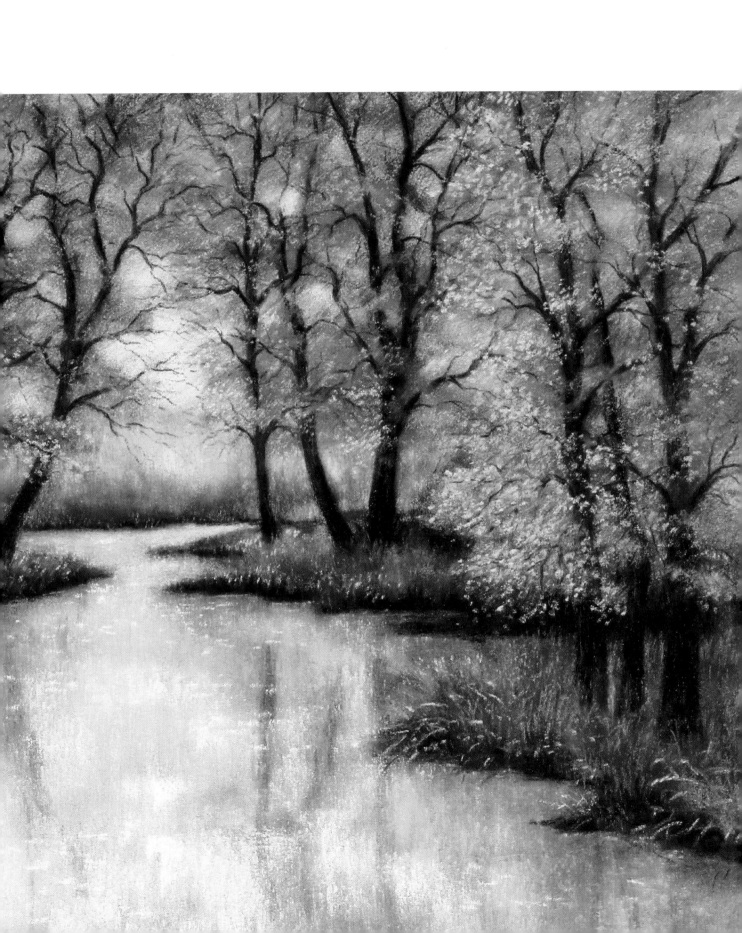

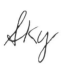

Sky

Painting the sky can be difficult; it's constantly moving and changing color. Painting in pastel makes it easier because it's such a quick medium! However, on a windy day, the speed of the clouds can still cause problems. One tip is to always keep a camera handy. As soon as you see that special cloud formation, run outside, and take a picture.

First draw a few very simple cloud formations with a pastel pencil. Position the most interesting cloud shapes in the central area of the painting.

Using the side of a pastel, block in the background. Starting in the top left corner, the colors move from dark to light across this painting. Highlight the central cloud formations in pale colors, and then add other pale colors to the lower clouds.

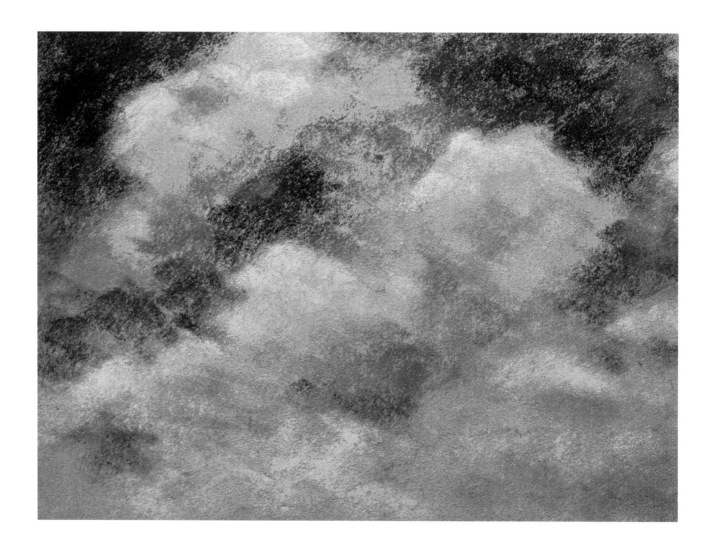

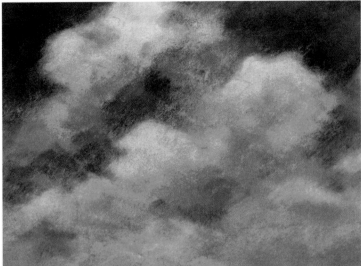

Blend the background colors from left to right. Add more depth, and continue blending using a circular motion to make the cloud formations appear more realistic. Leave some of the background showing through to help the overall look of the painting.

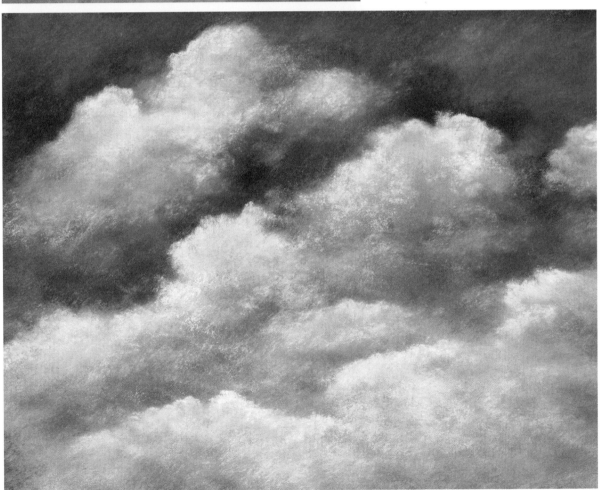

Continue to add colors, particularly dark blues and purples. Add lighter shades, and continue to blend with your fingers. Finally, create the outside edges of the clouds using the sharp edge of a white pastel stick.

Still Life

Flowers make lovely living subjects for pastel paintings. Still lifes give you complete control over your subject, as you choose the lighting, background, objects, and textures.

Sketch the outline loosely with a pastel pencil, making sure the pot is balanced and the flowers do not look too heavy. Use simple oval shapes for the flower heads and leaves.

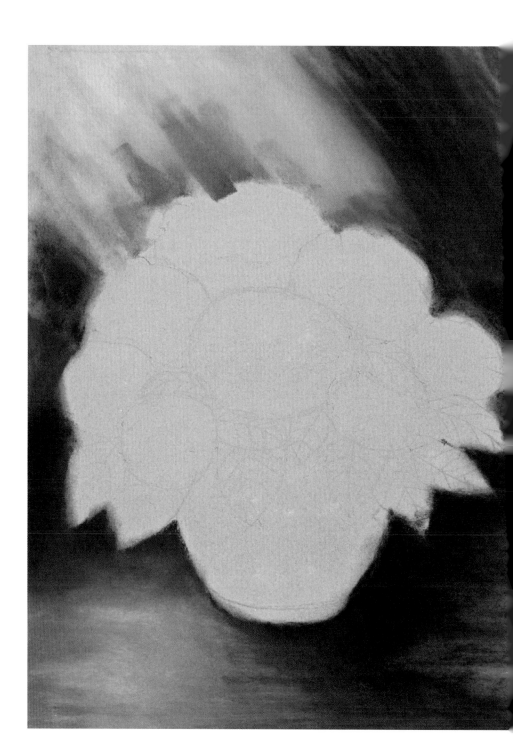

Fill in the shape and tone of the leaves, and add color to the flowers. Add warm shadows. Blending the pot into shape, create more shadows using dark browns, blues, and purples. Using a charcoal stick, place dark shadows.

Now bring back the strong, vibrant blues and purples. Create bright highlights using the chisel edge. Adding darker shades helps the overall composition.

Then soften the shadows and create depth by blending. Finally, show the light coming from the window on the bottom left.

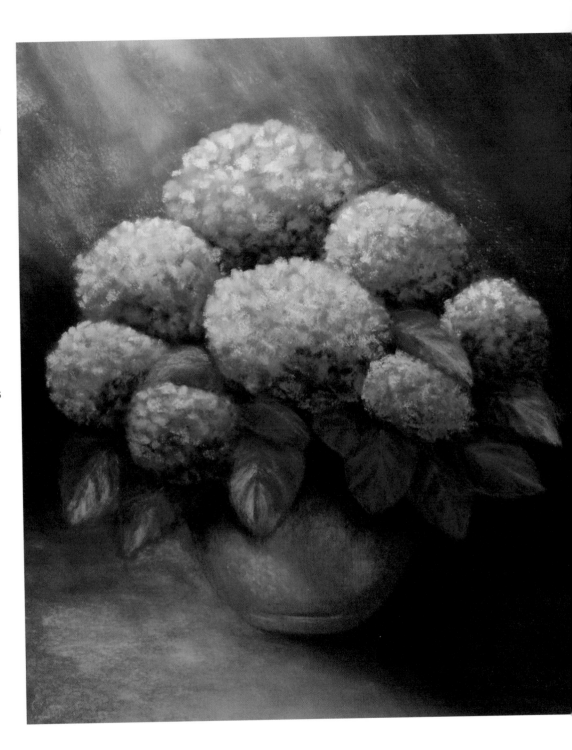

tip

LAYERING BRIGHTER SHADES OF COLOR LIFTS THE PAINTING.

Structures

Painting buildings presents a challenge to a pastel painter, as there are many details to include. However, by using a combination of soft pastels and pastel pencils, amazing results can be achieved.

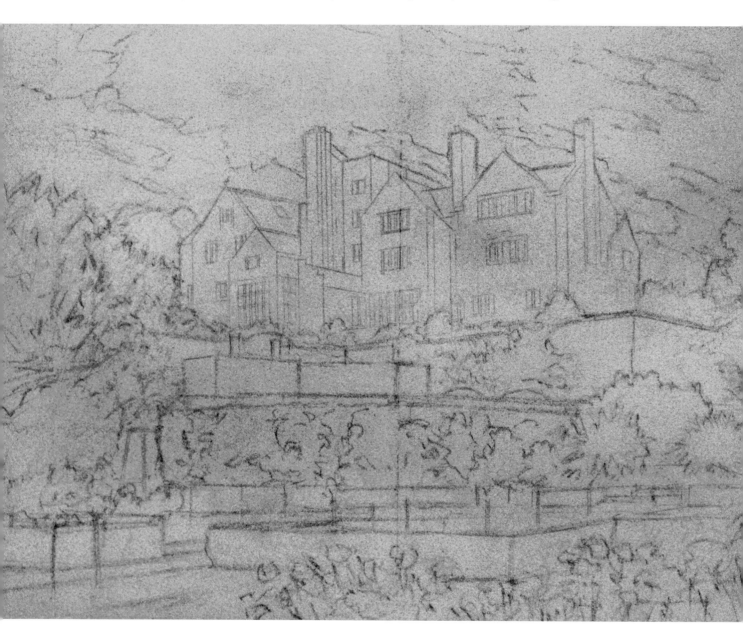

Draw the subject very lightly with a pastel pencil and charcoal stick. Note that the building is drawn in a different style from the gardens below. Draw the building accurately, using a ruler to maintain straight edges and the correct positioning of the windows and chimneys. Draw the garden more loosely.

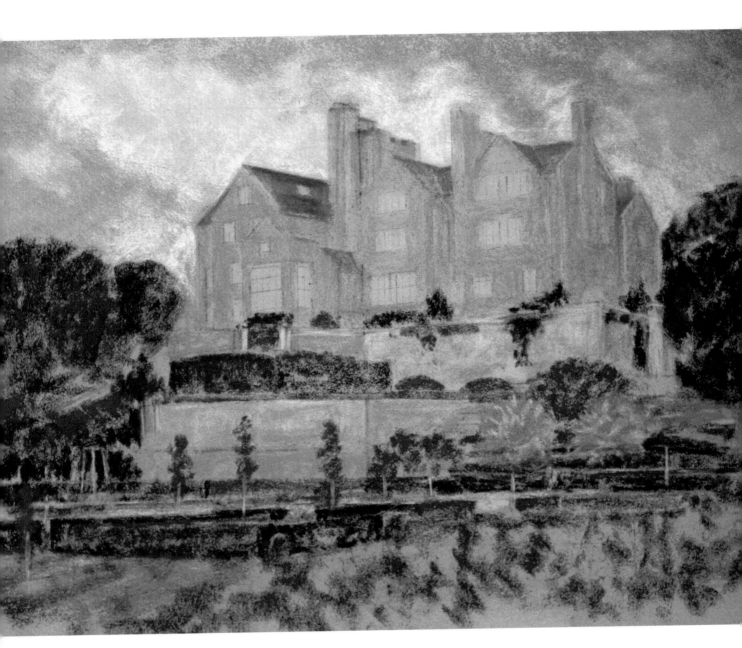

Block in the basic colors, remembering not to press on the pastel, as you need just a light coating at this stage. Leave a lot of the background surface showing through.

Block in the shapes of the trees, highlight the grasses and roof tiles, and add the walls of the building.

Gently rubbing all of the colors with your finger, fix the pastel onto the surface. Add windows to the building, and place pale highlights on the edges of the building and garden walls.

Lighten up the trees and grass, and add rose shapes to the tops of the flowers in the foreground. Add pale shades to the sky.

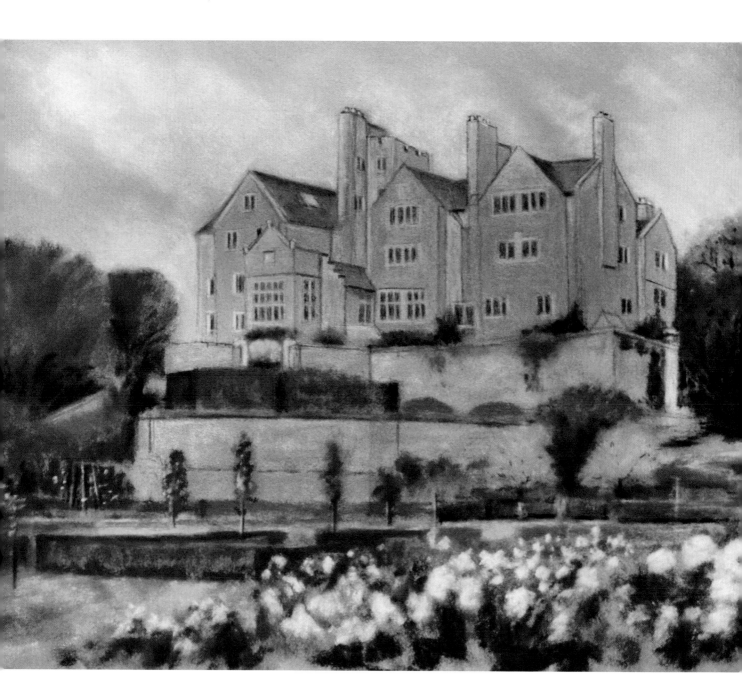

Add fine details to the building, sky, and gardens. Use a dark gray pastel pencil or charcoal stick for the tree trunks and branches. Highlighting the walls and steps of the garden to indicate areas of light, use pastel pencils for details on the flowers and trees. Finally, lighten up the grass to show the sun shining directly onto the garden.

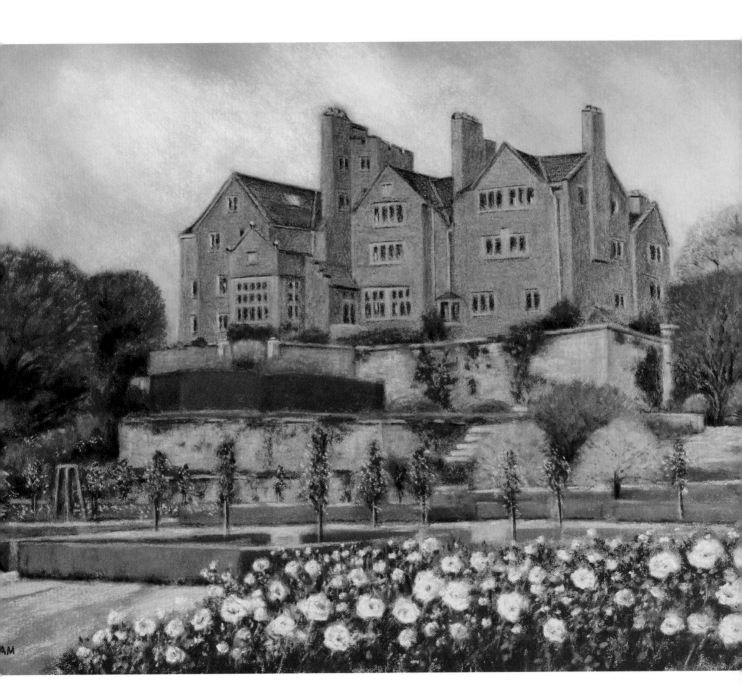

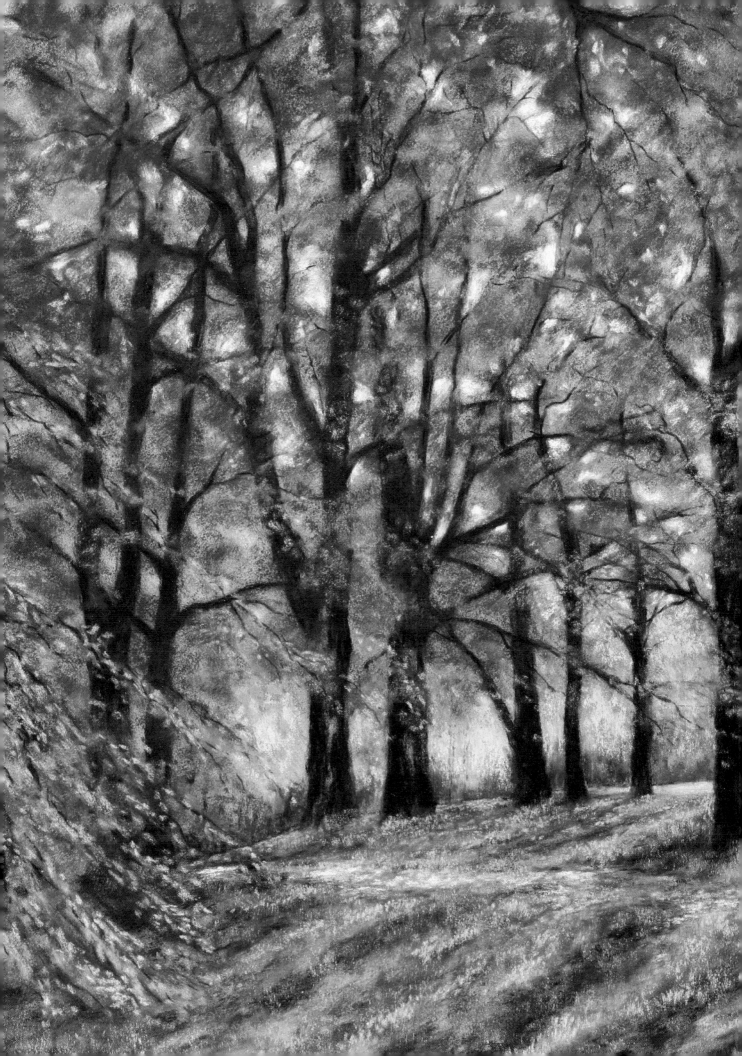

Mastering

WHAT YOU'VE LEARNED

Introduction

Now let's put your newfound skills into practice with eight painting projects. The projects here are divided into four sections covering spring, summer, fall, and winter. These projects will give you the unique opportunity to try the techniques you've read about and create your own beautiful pastel paintings.

Each project uses a color palette of 16 half-stick soft pastels, but feel free to choose your own colors if you prefer. Beginning on page 124, you'll find eight black-and-white drawings that you can copy and trace to begin each painting project. Try freehanding the sketches if you prefer not to trace—anything goes!

USING THE BLACK-AND-WHITE DRAWINGS

Each project has a corresponding black-and-white drawing. Carefully follow the step-by-step instructions below to create an outline of the composition, or sketch out your own drawing.

1. Copy the drawing onto lightweight paper.

2. Rub a dark pastel across the entire reverse side of the image.

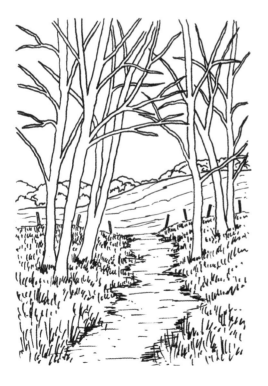

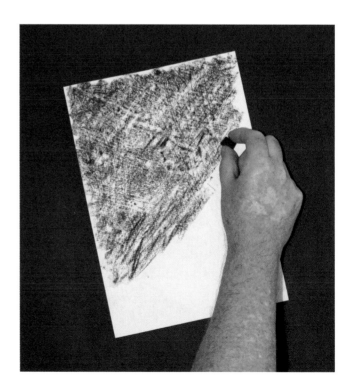

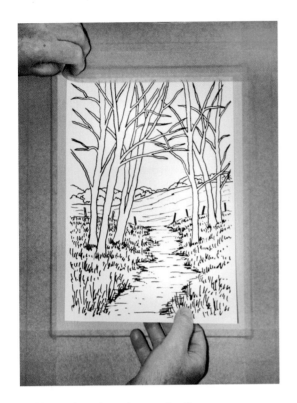

3. Tape the drawing onto the sanded card.

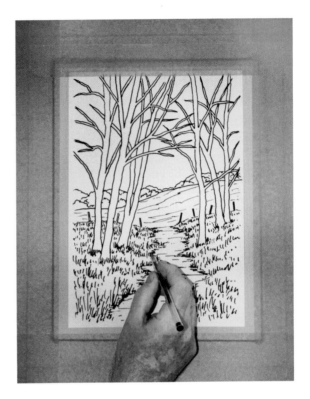

4. Use a pen to lightly trace the image.

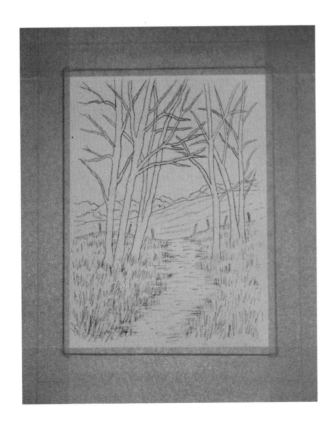

5. Peel off the black-and-white drawing to reveal your outline. Trace over the image with a soft black pastel pencil if it looks too light.

Starting with Spring

The Laburnum Arch in Wales' Bodnant Garden features beautiful flowers in spring, when it becomes a vast, vibrant cascade of golden yellows and greens. Try creating your own pastel painting of this gorgeous springtime scene, or use these tips whenever you paint flowers and trees.

COLOR PALETTE

Peach pink, dark brown, mid-brown, pale pink, dark green, mid-green, light green, golden yellow, mid-yellow, pale yellow, bright blue, mid-blue, pale blue, dark purple, mid-purple, and white

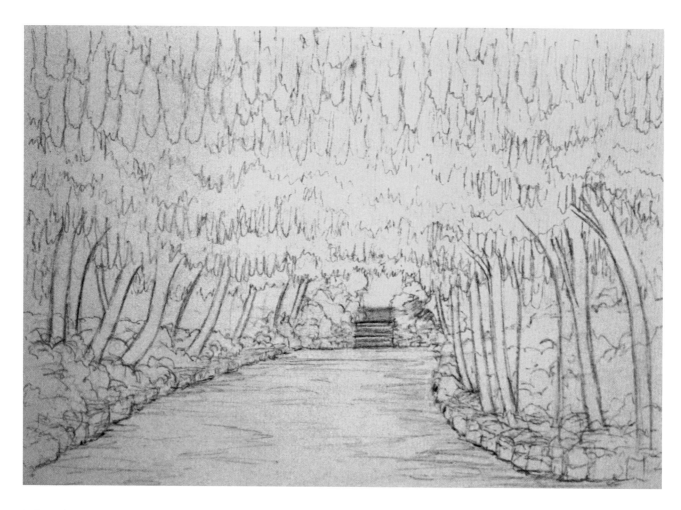

When beginning a pastel artwork, start with a loosely drawn subject. Gently outline where you want to place each element.

Layer in certain details with the flat side of a pastel. Also add shadows and light. Create flower stems using downward strokes across the page. Using the side of a pastel, distribute flowers under the trees, and use the chisel edge of a darker shade to place bushes and flowers on the sides.

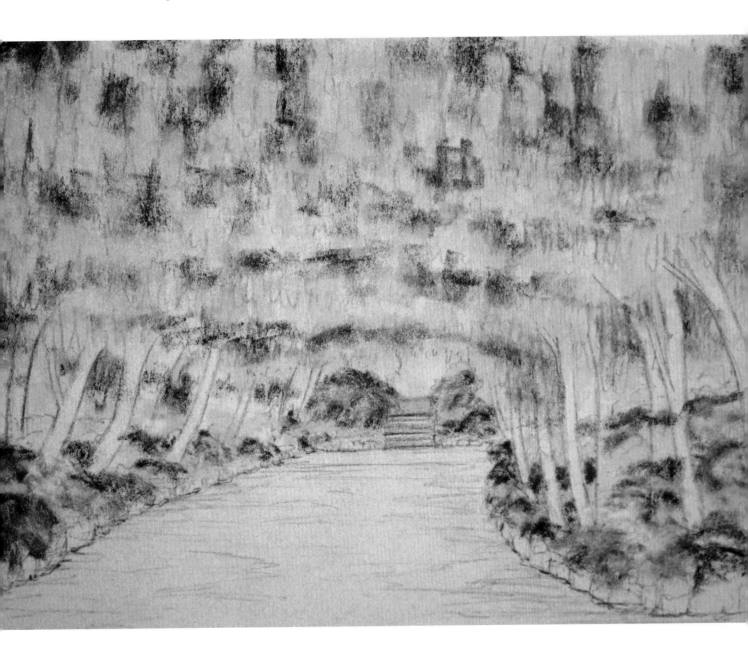

tip

THE LIGHTER YOUR HAND IS, THE MORE EFFECTIVE THE SHADING WILL BE.

Use the chisel edge of a pastel to bring contrast to the tree trunks and lower walls in the foreground and the end of the path near the steps. This adds interest to the painting. Also create an interplay of shadows along the path.

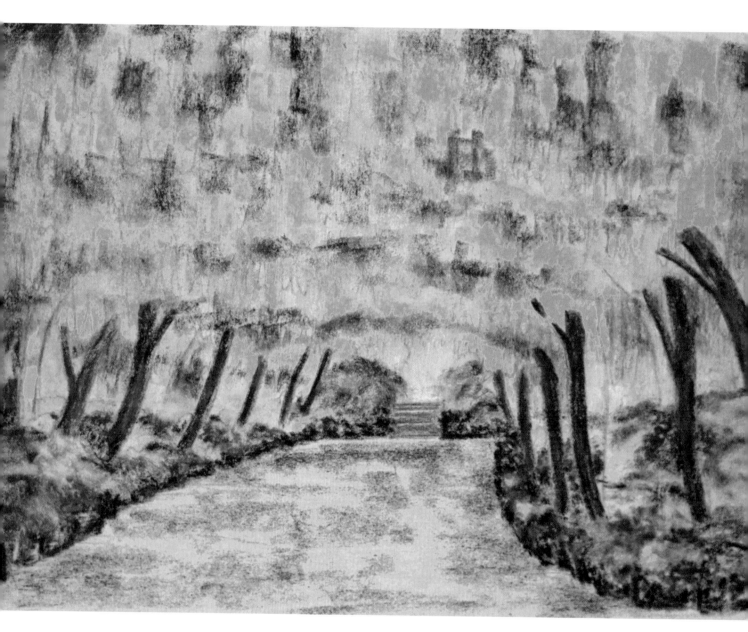

ADD SMALL AREAS OF LIGHT AMONG THE TREES FOR CONTRAST.

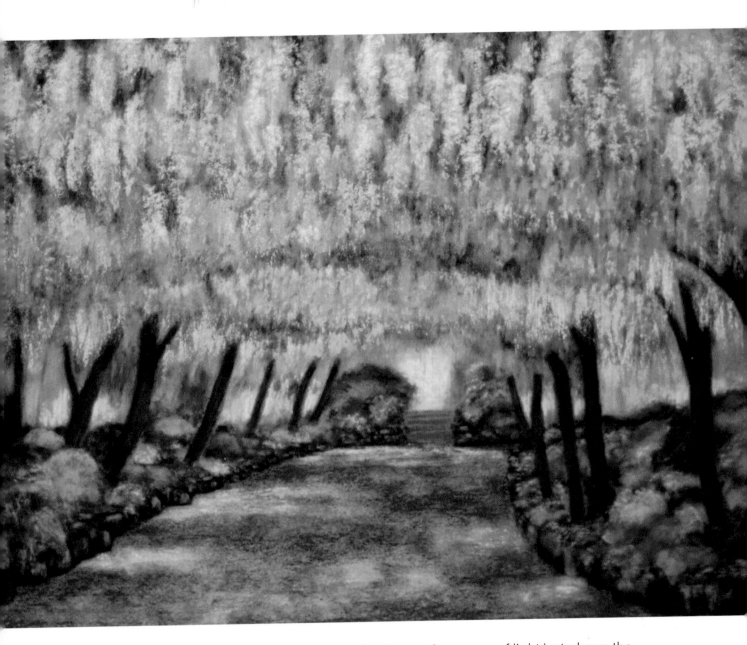

To gain the most dramatic effect from the darker shades, craft an area of light just above the steps at the end of the tunnel to indicate a patch of sunlight. Use the sharp edge of a pastel for the sides of the steps. To prepare the painting for the next stage of light and shade, gently rub the pastel into the background in the direction of the subject.

Use the sharp end of a charcoal stick to create shadows and darken the tree trunks and walls. Then add small, detailed flowers with the chisel edge of a pastel.

Use downward strokes and the flat side of the same pastel to create small hanging flowers and provide perspective on the underside of the arch and highlights across the path, tree trunks, and flowers above the wall. Add light over the stones of the lower walls, and strengthen the darker shadows on the path.

Now you can add more flowers. Also create areas of sunlight across the bushes and through the flowers to convey a springtime atmosphere and complete the painting.

tip

GENTLY RUB FROM LEFT TO RIGHT TO FLATTEN THE SHADOWS AND MAKE THEM LOOK MORE REALISTIC.

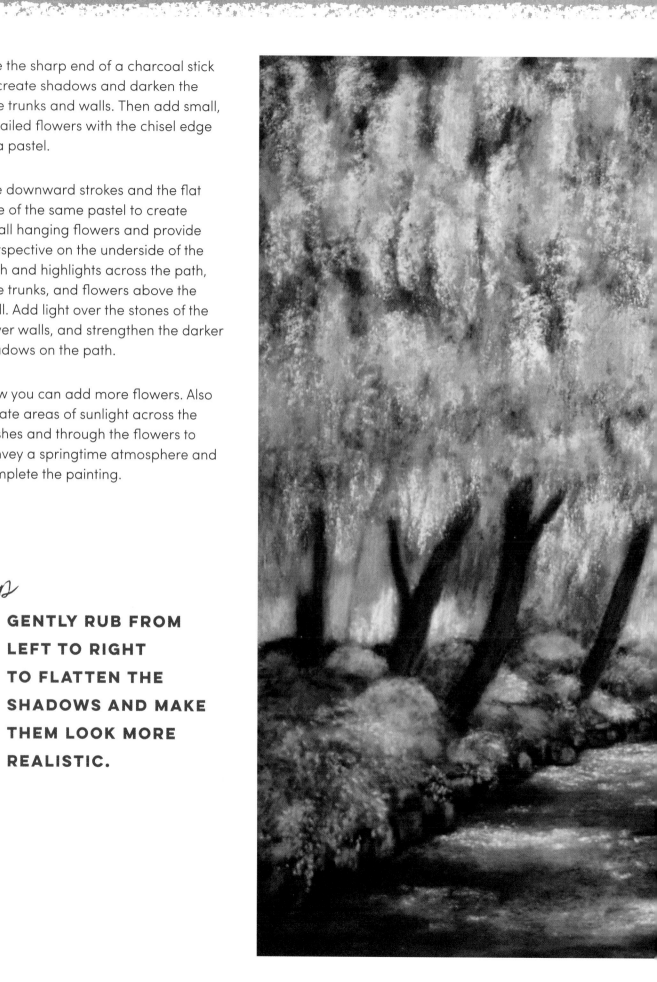

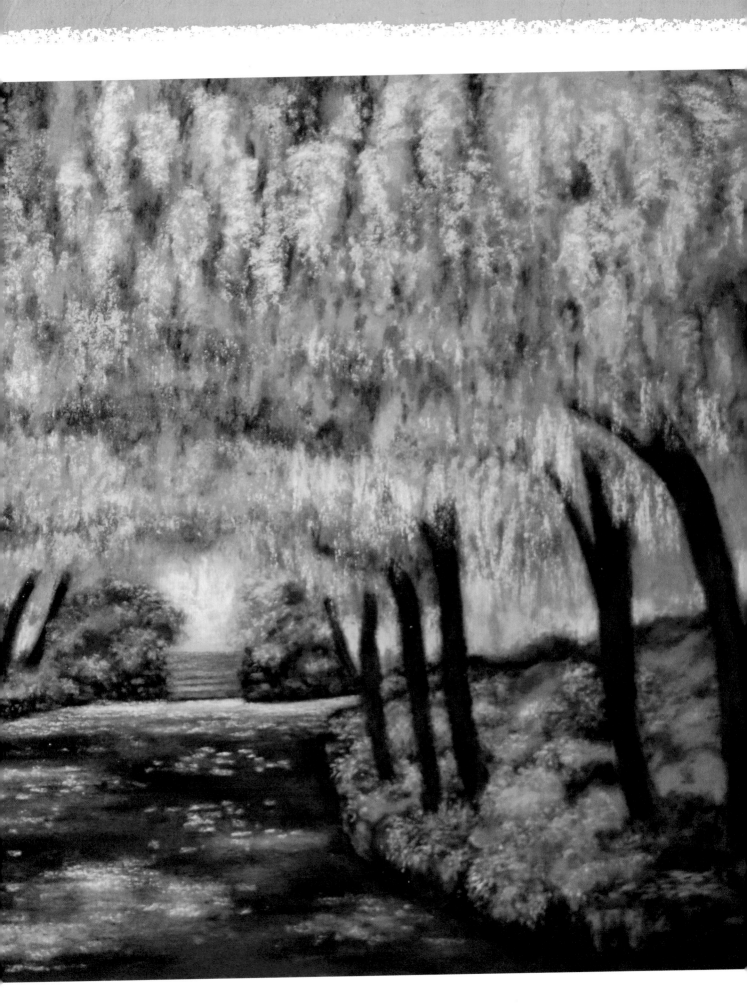

Painting a Springtime Landscape

Spring is a wonderful season for painting landscapes. The intensity of the bright greens in the fresh new growth of the grass and trees can be stunning. The appearance of flowers brings hope of sunny days to come and makes spring a wonderful time of year to paint.

COLOR PALETTE

Peach pink, dark brown, mid-brown, pale pink, dark green, mid-green, light green, golden yellow, mid-yellow, pale yellow, bright blue, mid-blue, pale blue, dark purple, mid-purple, and white

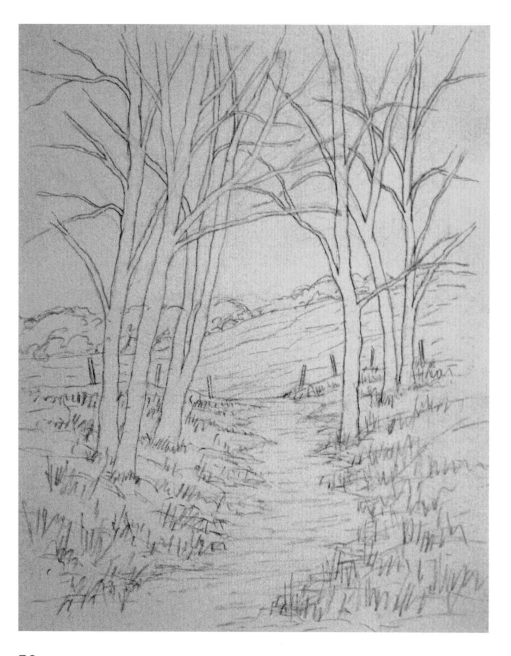

Using a soft pastel pencil, draw the outline of the painting in a loose style.

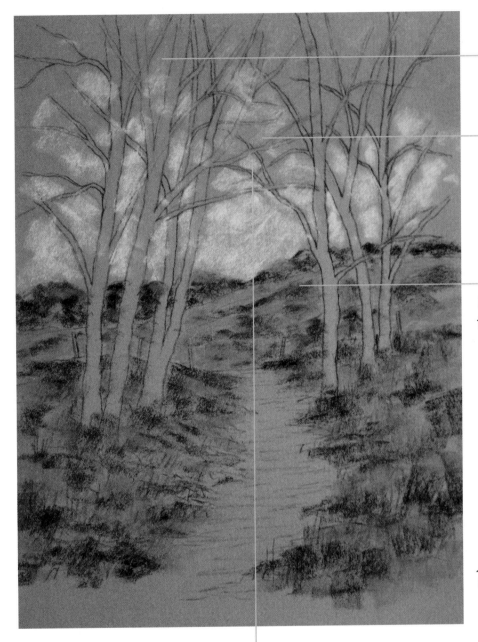

Use the flat side of a pastel to block in areas of sky.

Add a fine layer to indicate clouds.

Lightly stroke a fine layer over the trees, meadow, and along the path using two shades of green to add contrast.

Let some of the background show through.

tip

DO NOT PRESS TOO HARD ON THE PASTEL; DOING SO WILL FILL IN THE "TOOTH" AND MAKE IT DIFFICULT TO ADD MORE LAYERS.

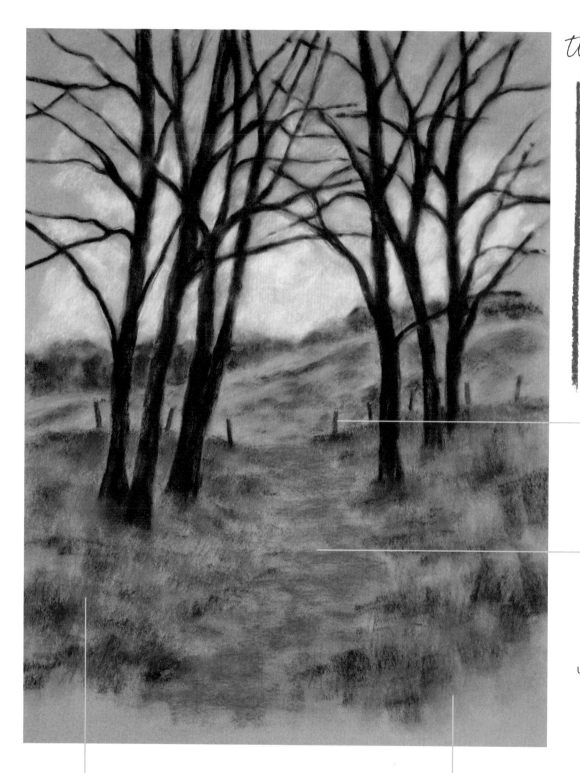

tip

BLEND THE DARK COLORS FIRST, AND THEN MOVE ONTO THE LIGHTER SHADES. REMEMBER TO CLEAN YOUR HANDS BETWEEN COLORS.

For details like the fence, use the sharp edge of a charcoal stick.

Hold a pastel horizontally between your thumb and forefinger, and use the flat side to create a base for the path.

Block in flowers with the flat side of a pastel.

Carefully and lightly blend the pastels into the background.

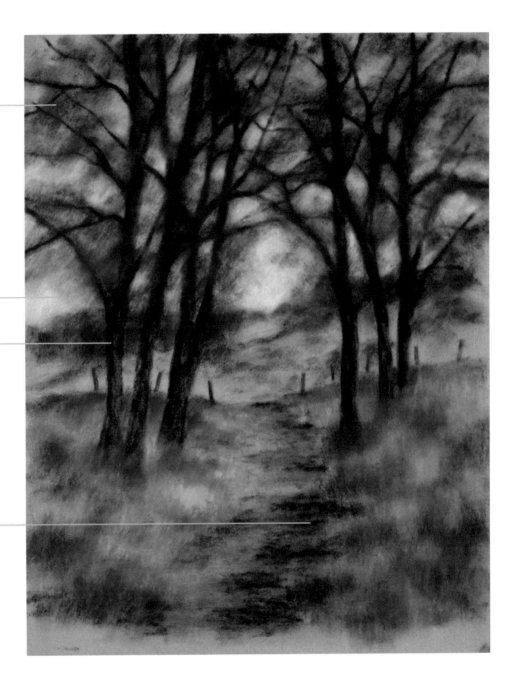

The flat side of a pastel works well for creating leaves.

Highlight areas of sunlight.

Create highlights on the trees using the chisel edge.

Use the chisel edge to add shadows.

tip

THE FLOWERS IN THE FOREGROUND SHOULD BE LARGER THAN THE ONES IN THE MIDDLE DISTANCE TO GIVE YOUR PAINTING A SENSE OF PERSPECTIVE.

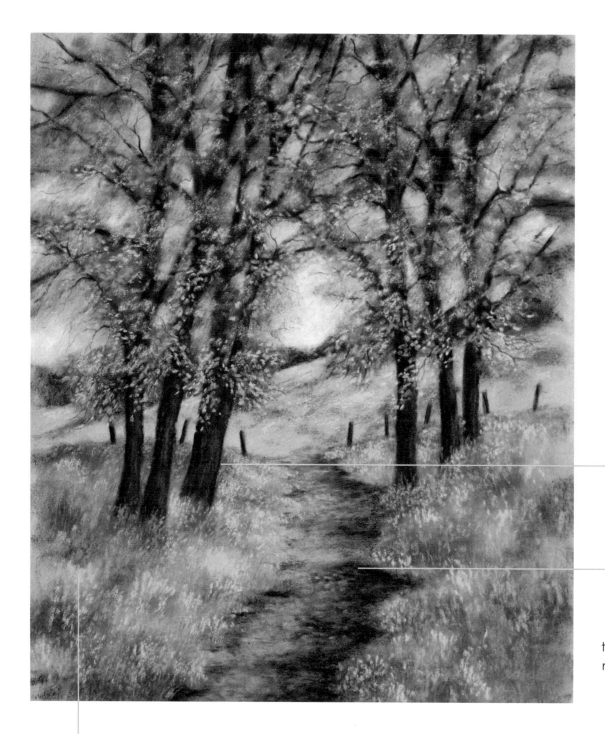

Fine lines
represent
bark.

Use your
fingers or
a blending
tool to gently
rub the dark,
shadowed
areas.

Create fine grasses.

tip

**CREATING ANOTHER TONE FOR THE
FLOWERS WILL MAKE YOUR PAINTING
MUCH MORE INTERESTING.**

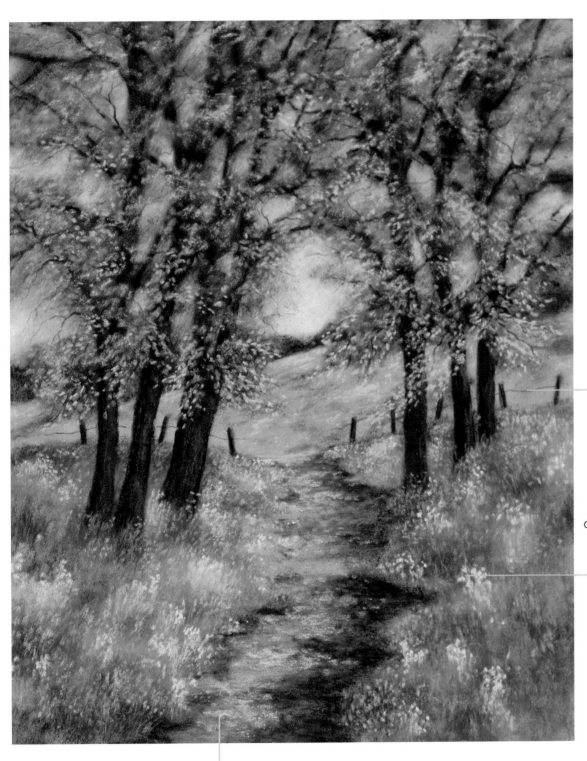

Use the sharpened edge of a black pastel pencil to add the wires connecting the fence posts.

Additional details like smaller flowers and leaves make your painting come alive.

Intensify the patches of sunlight with the sharp edge of a pastel.

Setting the Scene for Summer

The boathouse is the main feature of this painting, although the trees that surround the pond are stunning too, setting the scene for a glorious summer day! When painting a summer scene, remember that typical colors include bright blues, white, and greens. Gradually add layers to create an accurate reflection.

COLOR PALETTE

Bright red, pink, dark brown, mid-brown, dark green, mid-green, pale green, lemon yellow, golden yellow, dark blue, mid-blue, pale blue, lilac, pale lilac, gray lilac, and white

Start with a loosely drawn subject. Outline where you want to place each element.

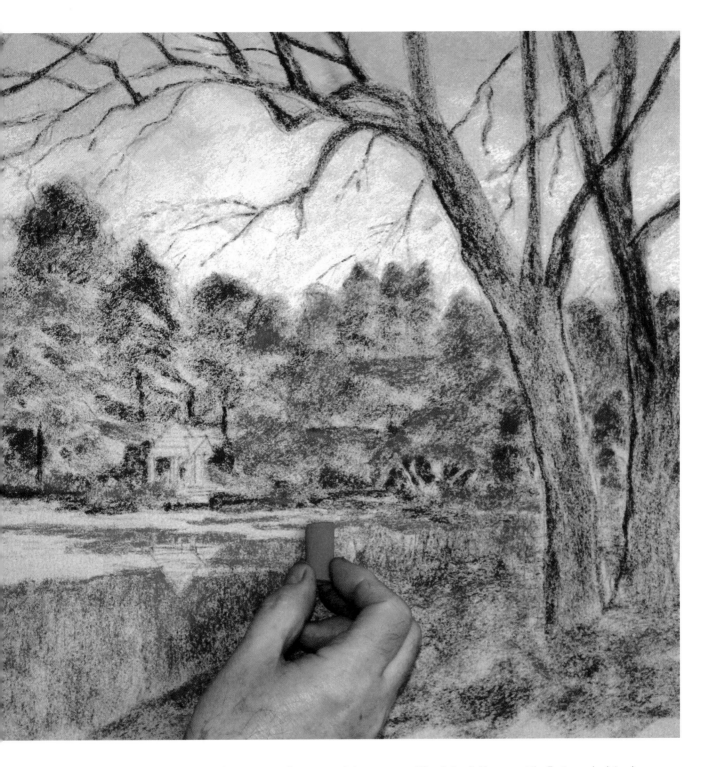

Layer in the sky from left to right across the top of the page. Block in foliage with flat and chisel edges, working from the left side of the paper and upward. Then highlight trees and grasses using various edges of the pastel to create differing effects. Fill in the tree trunks and form finer branches and twigs, and use the sharp edge of a pastel to indicate water.

Use a mid-brown pastel to outline the shape of the boathouse in its reflection on the water, creating a realistic image among the lily pads. Distribute areas of sunlight throughout the distant trees, and use a layer of pale green on the banks of the pond to highlight the taller grasses in the bottom left corner.

Sharpen the boathouse and the tree trunks with the point of a black pastel pencil. Emphasize darker shadows around the building and under the trees, and add another layer of mid-green to fill the shadow areas of the trees and fields and add depth to the picture.

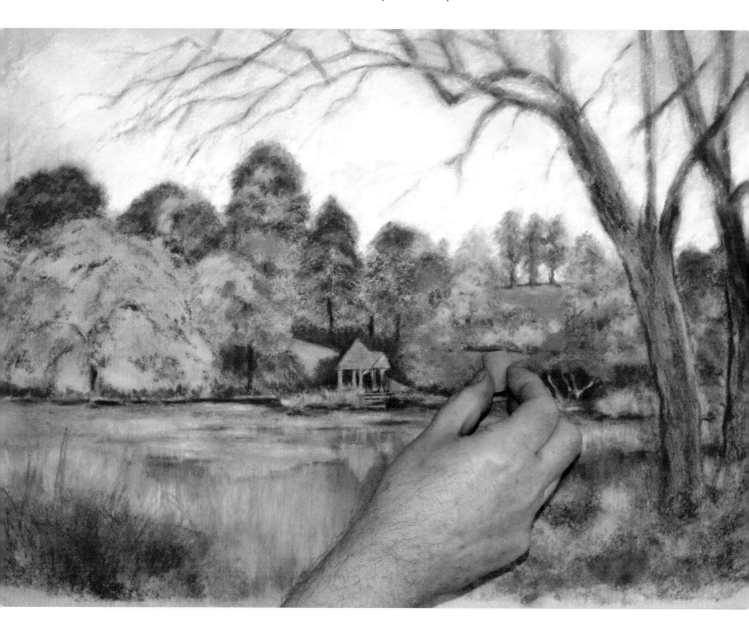

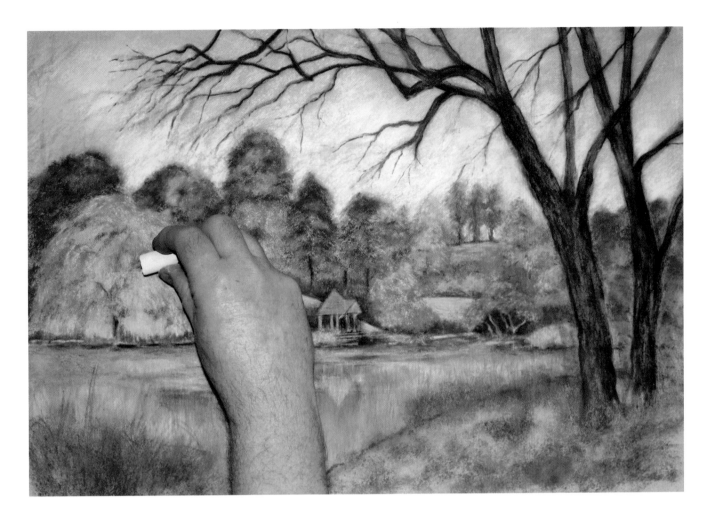

Darken the main trees in the foreground with a charcoal stick. Use the sharp edge to highlight the small branches and twigs. The tree trunks should contain fine lines that resemble bark.

Create light and shade by gently stroking the flat side of a mid-green pastel over the trees. Leave the foreground grass in shade. Then highlight the distant trees and fields to indicate strong sunlight, again using the flat side of the pastel.

Use the point of your smallest finger to smooth in the colors in the tree. Then press the tree trunk firmly with your thumb, following a downward movement. This will fix the color into the background.

tip

AVOID RESTING YOUR HAND ON THE PASTEL SURFACE TO PREVENT SMUDGING.

Use a sharp black pastel pencil to indicate shade. Continue using the pastel pencil to increase the darker shades inside the boathouse and underneath the trees.

Use the flat side of a dark green pastel to create shadows of leaves across the branches and trees. With the sharp edge, draw small bushes and ivy around the base of the trees, and create tall grasses in the left corner of the painting. Using the chisel edge, add a layer of mid-green over the shadows around the trees, the shore, and the grasses surrounding the front of the lake.

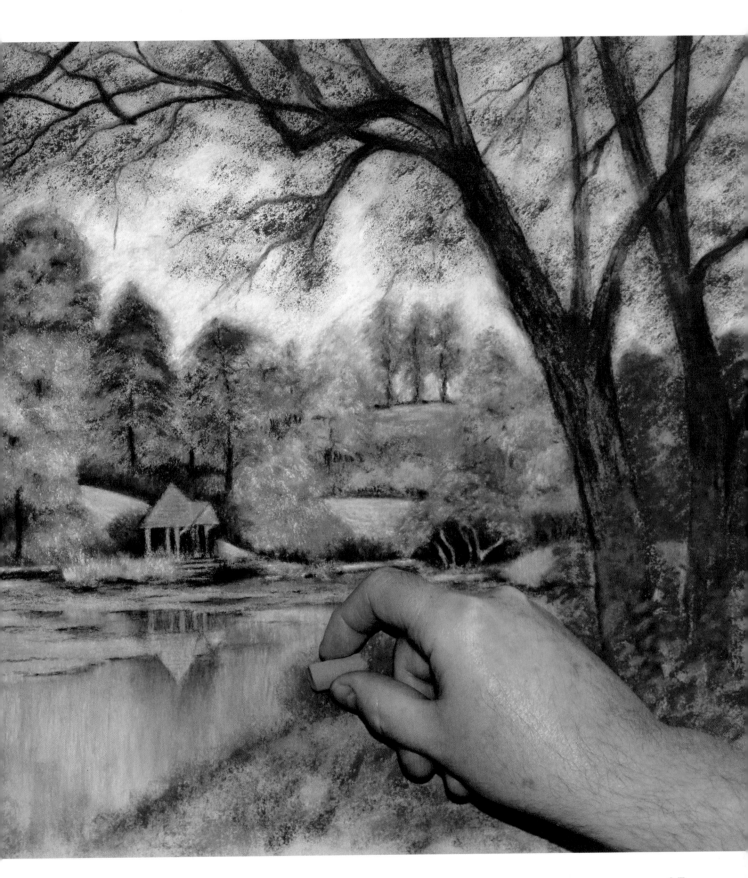

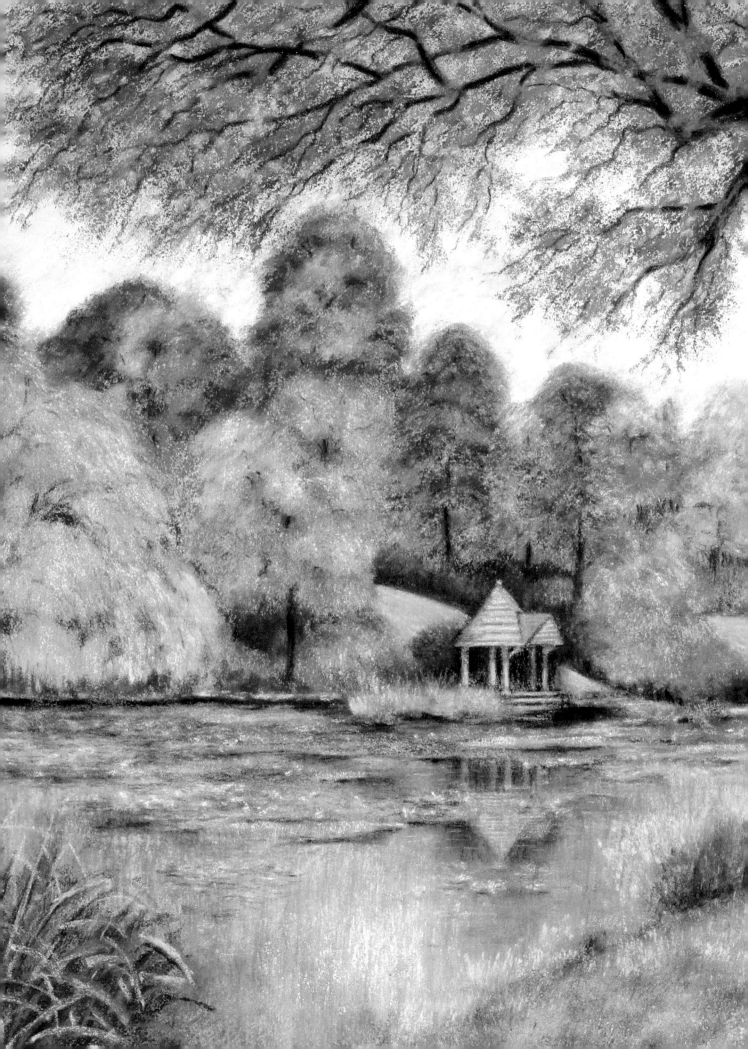

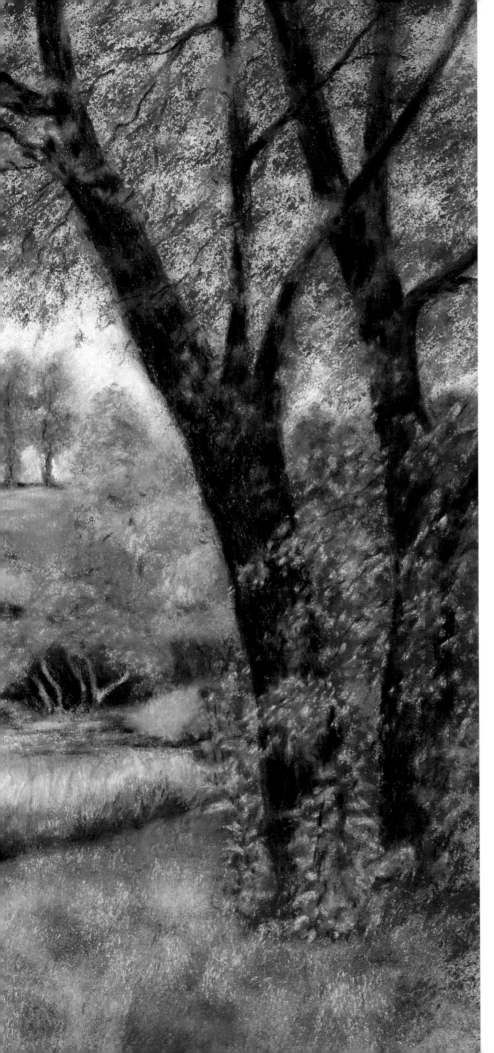

Highlight the plants, grasses, and leaves surrounding the bottom of the tree trunks in the foreground. Also sharpen the grass on the left. Darken all areas of the trees, paying particular attention to the fine twigs at the end of the branches and the smaller leaves. Create shadows along the edges of the grass in the foreground.

Add light to the boathouse. Use a white soft pastel pencil, and gently stroke over the surface of the lake in short horizontal lines. Highlight the lily pads, and create small flowers on top of them. Then, very carefully, place a tiny speck of bright red pastel in the flowers.

INDICATE SLIGHT MOVEMENT IN THE SURFACE WATER AND ADD A SENSE OF REALISM TO THE REFLECTIONS.

Stunning Summer Sunset

Sunsets are awe-inspiring subjects, and trying to capture the brilliance of their colors has challenged artists for centuries. This particular sunset has everything: Deep reds, purples, and blues at the top of the sky make way for golden yellows just above a calm sea at the horizon. Remember to blend the pastels to create a believable sunset featuring soft, gradated colors.

COLOR PALETTE

Bright red, pink, dark brown, mid-brown, lemon yellow, golden yellow, dark blue, mid-blue, pale blue, lilac, gray lilac, and white

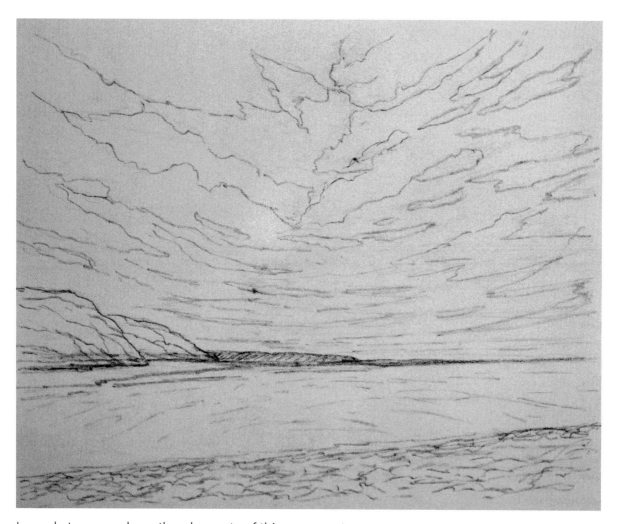

Loosely trace or draw the elements of this scene onto your paper.

Follow the shapes of the clouds toward the central area of the painting.

Very lightly stroke the flat side of a pastel across the sky.

Block in the clouds' shadows with the flat side of a pastel.

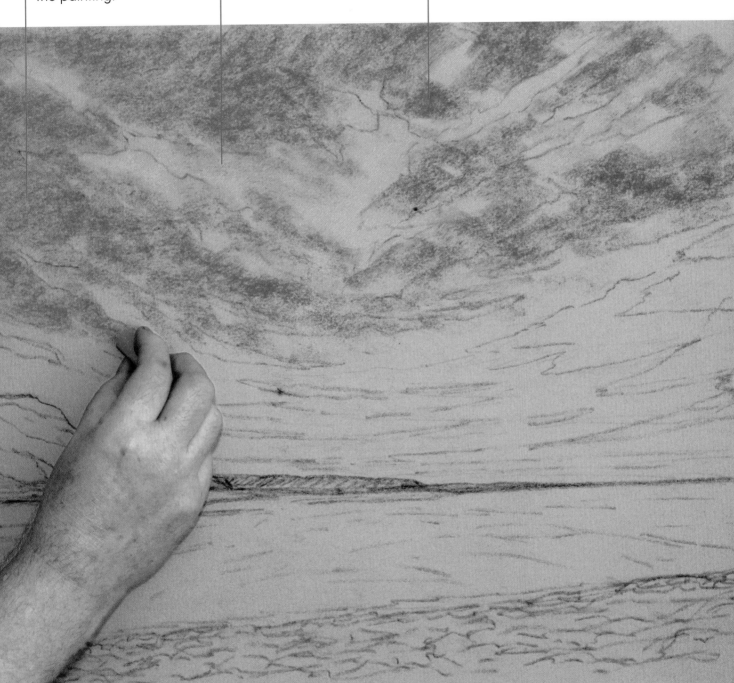

THE CLOUDS POINT TOWARD THE SUN SETTING BEHIND THE CENTRAL PART OF THE DISTANT ISLAND AND GROW SMALLER AS THEY REACH THE HORIZON.

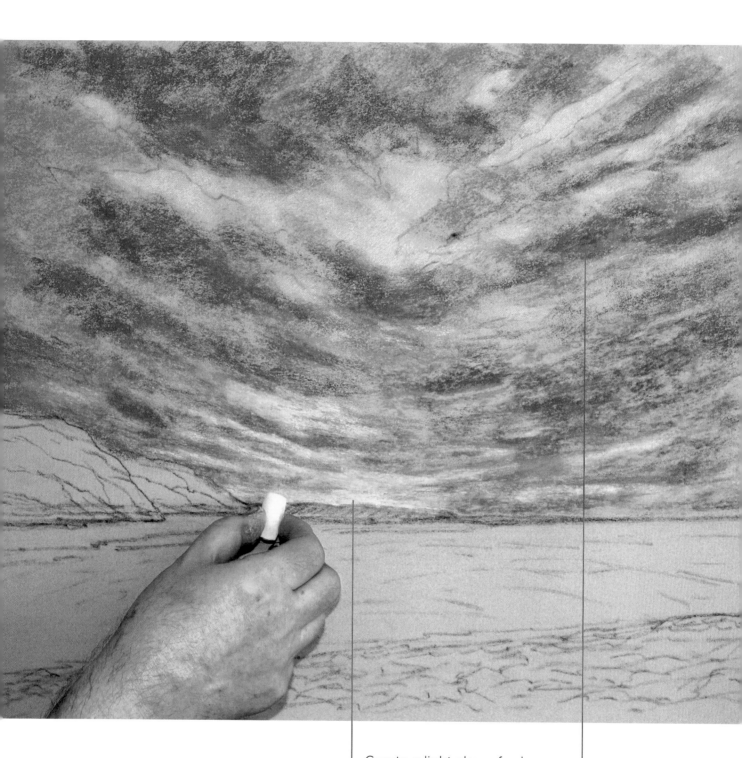

Create a light glow of color just above the horizon. This indicates the exact point where the sun sets behind the distant island.

Highlight the vibrant glow of the sunset.

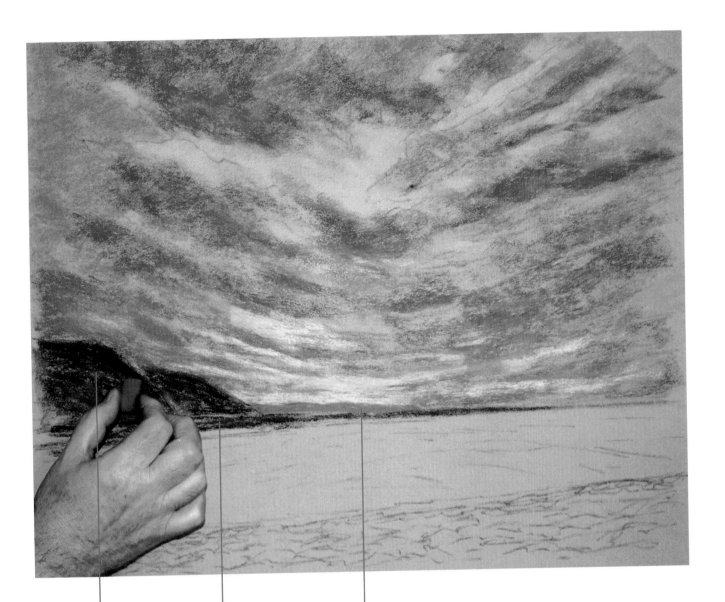

Highlight the distant island positioned just above
the horizon with the chisel edge of a pastel.

Develop the
silhouettes of
the two rocks.

Create a strong shadow
of the rocks in the water.

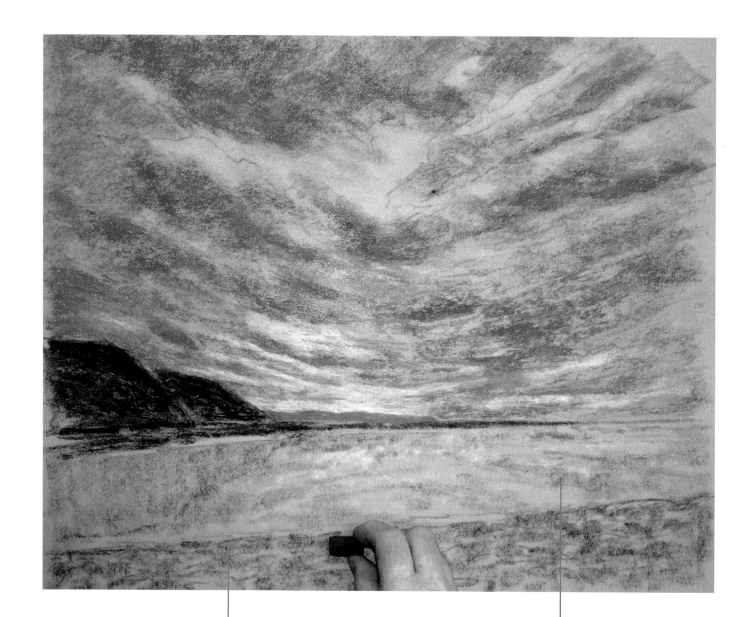

Create the impression
of rocks on the beach
with the flat side of a
darker pastel.

Lightly run the flat
side of three colors
of pastel over the
sea to create areas
of reflection from
the sky.

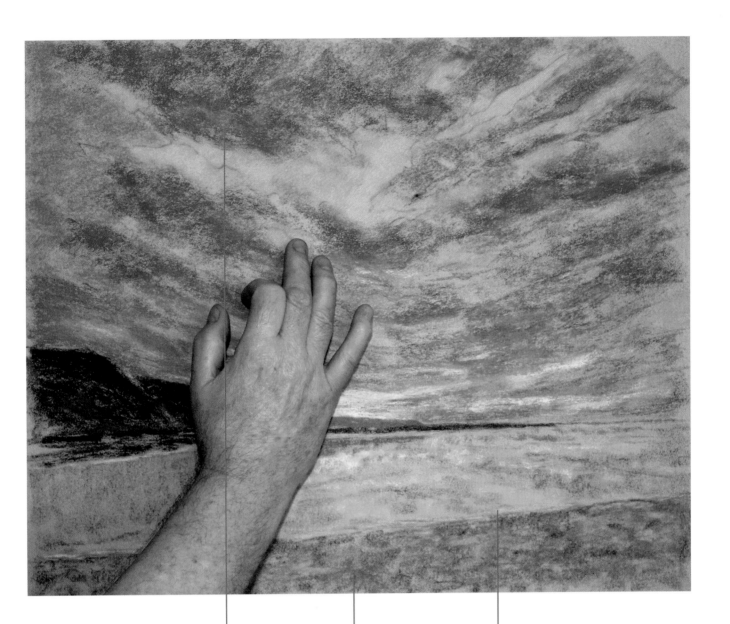

Gently rub the pastel into the surface to fix the colors into the background and create the underpainting.

Highlight the rocks on the beach with a fine layer of blue.

Create waves on the shore.

ADD THE NEXT LAYER OF PASTEL TO CREATE LIGHT AND SHADE.

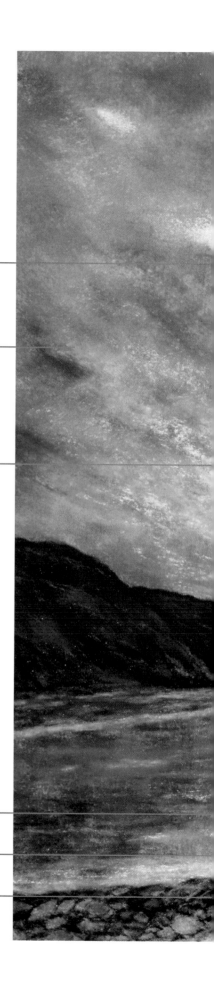

Gently create small clouds that indicate movement across the sky.

Add pink and other light layers to the sky.

Lightly cover the clouds with yellow to add vibrancy to the sky.

Short horizontal lines indicate small waves in the water.

Highlight the waves at the edge of the shore.

With a black pastel pencil, outline the rocks on the beach to convey a rocky shoreline.

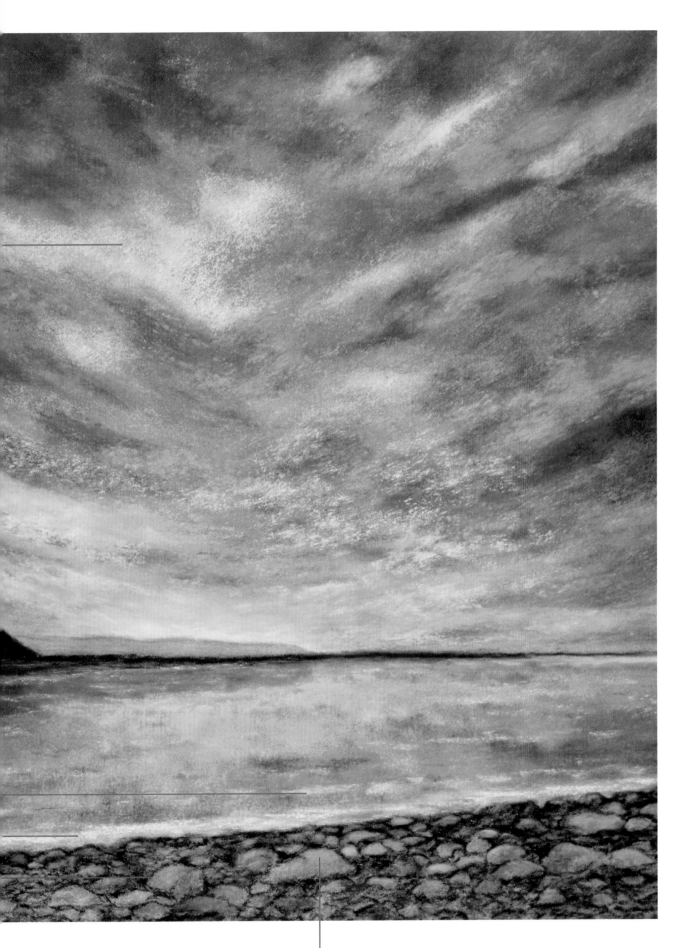

Add light and shade to the rocks.

Reflecting on Fall

There is nothing better than seeing the vibrant reds and browns of the trees reflecting in a river on a beautiful autumn day. Capturing this magnificent scene for others to appreciate is an enjoyable exercise.

COLOR PALETTE

Deep red, rust red, dark brown, mid-brown, golden yellow, mid-yellow, pale yellow, cream, dark green, mid-green, light green, pale blue, dark purple, mid-gray, light gray, and white

Using a soft pastel pencil, draw the outline of the painting in a loose style.

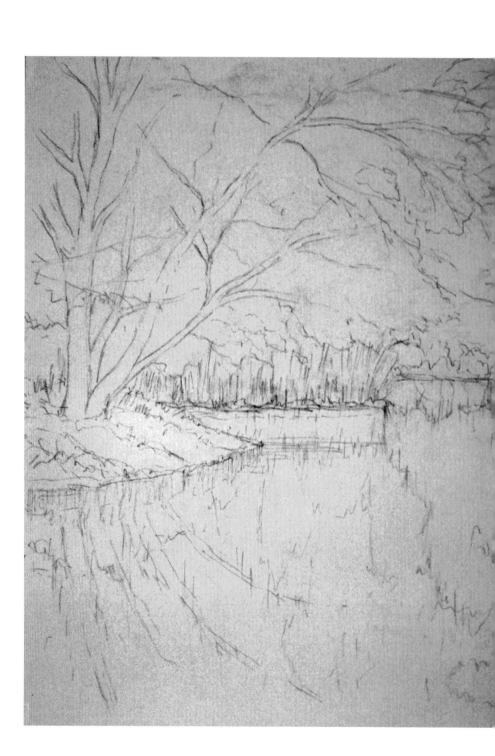

THE LIGHT SOURCE IS ABOVE THE TOP RIGHT CORNER OF THE PAINTING.

Use the flat side of a deep red pastel to block in leaves across the trees. Using the flat side of mid-brown, block in more leaves. Indicate leaves coming in from the right side.

Use the flat side of mid-yellow to add light-colored leaves to the right side of the painting.

Using the flat side of the dark green pastel, create areas of green between the trees. Darken the shadows. Then use the chisel edge to block in dark shadows between the tree trunks. Add a light layer of dark green to create reflections in the water.

tip

WITHOUT PRESSING TOO HARD, MOVE THE PASTEL IN A SINGLE STROKE VERTICALLY TO CREATE REALISTIC REFLECTIONS.

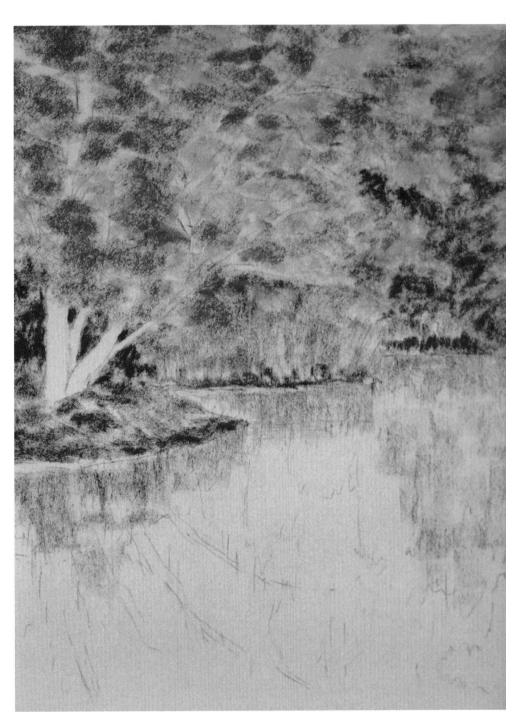

Next, block in dark brown tree trunks and branches using the chisel edge. Then, using the flat side, create shadows at the base of the reeds, the tree trunks, and the edge of the shore. Use the flat side to add shadows of branches reflecting in the water.

Block in the shadows of the trees reflecting in the water using the flat side of the dark red pastel.

Add more reflections to the water using the flat side of the rust red pastel, and create another layer over the top of the deep red shades.

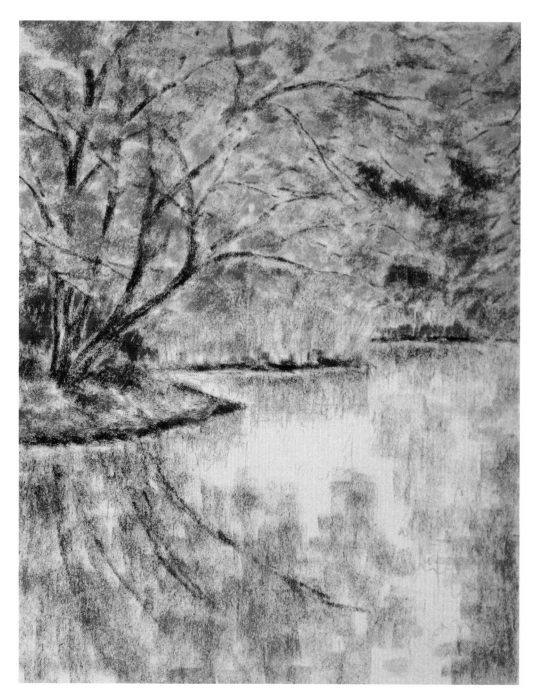

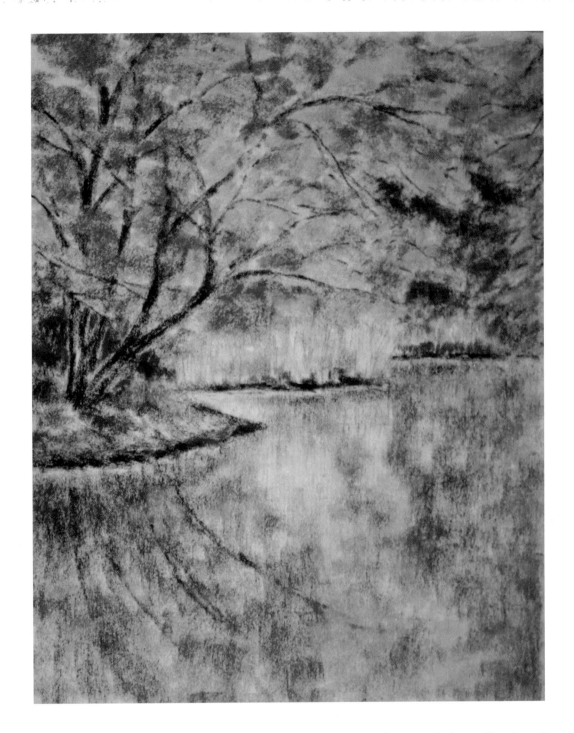

Continue to layer color over the reflections in the water. Block in the remaining reflections by mirroring the dark trees. Again, add a light layer of pastel in vertical blocks of color.

Add pale green highlights to the reeds in the central area of the painting by placing a light layer of pastel over the dark green reeds.

Using your fingers or a blending tool, gently rub the colors into the background.

Use the chisel edge of the golden-yellow pastel to create leaves. Using the flat side of the pale green pastel, add light to the reeds. Also use this technique to create reflections in the water.

Use the flat side of the mid-yellow pastel to create a thin layer of leaves.

Create small areas of deep red leaves across the whole tree area. Make them darker on the left side and lighter toward the sunlight.

Use the charcoal stick to draw the tree trunk, branches, and twigs. Create shadows in the water. Use the sharp edge of the golden-yellow pastel to indicate movement in the water. Use the flat side of the pastel to create light reflections on the water and add sunlight to the trees. Intensify the dark shadows in the water.

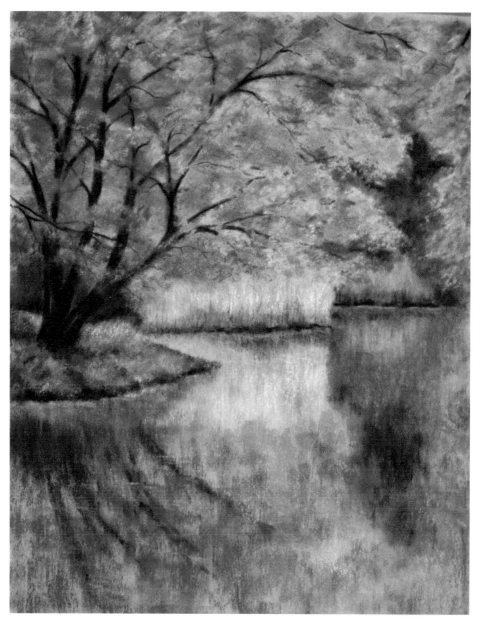

tip

YOU CAN ADJUST THE TONE OF YOUR COLOR BY VARYING THE AMOUNT OF PRESSURE YOU APPLY.

Add fine highlights of pale yellow to indicate ripples in the water. With a mid-green pastel pencil, create small grasses. Highlight the pale green reeds below the trees and indicate a few lily pads.

Create more ripples in the water around the bottom half of the painting. Using a mid-gray pencil, add some highlights to the large tree on the left, the bark, and some of the branches.

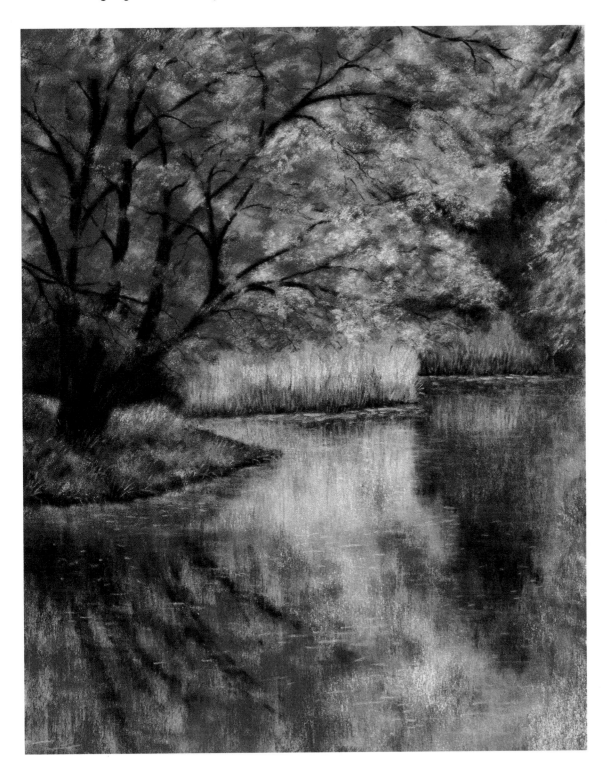

Conveying Fall Colors

Autumn is a feast for the eyes with a fantastic display of brilliant reds, beautiful browns, and golden yellows. Block in and layer colors to create your own fall forest scene.

COLOR PALETTE

Deep red, rust red, dark brown, mid-brown, golden yellow, mid-yellow, pale yellow, cream, dark green, mid-green, light green, pale blue, dark purple, mid-gray, light gray, and white

Using a soft pastel pencil, draw the outline of the painting in a loose style.

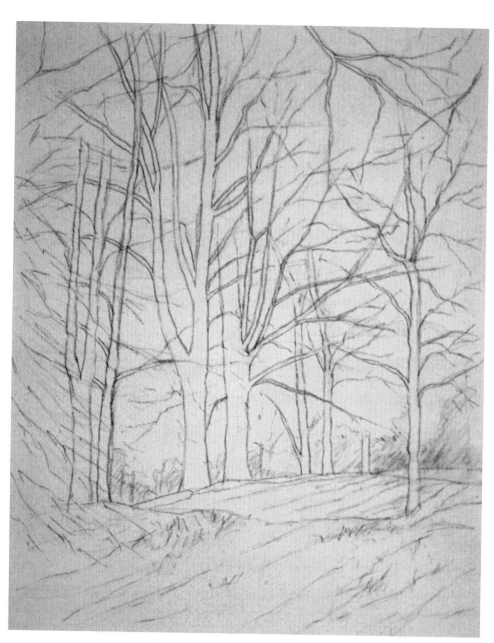

Paint the sky holes using the chisel edge.

Block in the leaves.

Place light highlights in the treetops with the flat side of a yellow pastel.

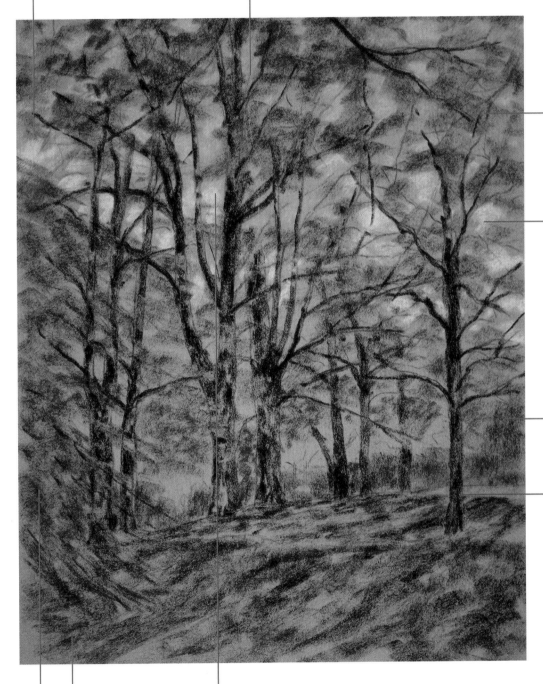

Indicate clouds peeping through.

Use the chisel edge to highlight the foliage.

Also use the chisel edge to block in the tree trunks.

Use the flat side to paint fallen leaves.

Place a light covering to indicate sunlight coming through.

Create shadows with the flat side of a pastel.

Indicate light in
the foreground.

Going from
dark to light,
gently blend the
pastel into the
background.

Darken the
tree trunks and
branches with a
black charcoal
stick.

Use your finger or
a blending tool to
push the pastel
in the direction
of the various
elements.

Use the chisel
edge to add small
leaves.

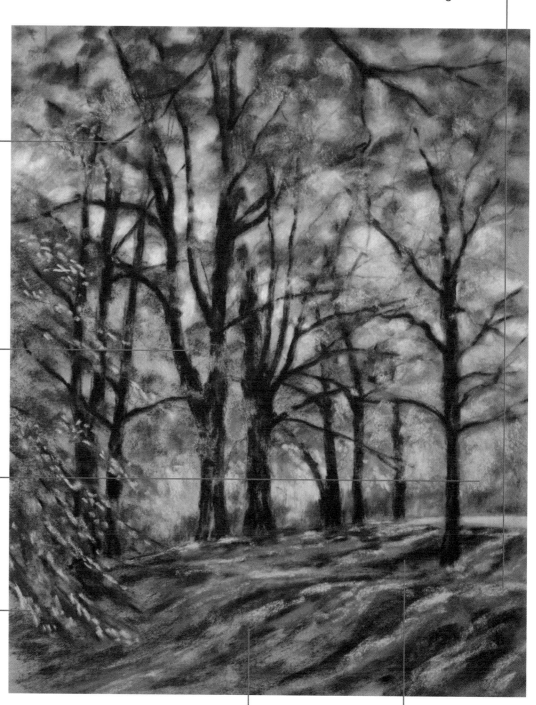

Use the flat and
sharp edges to add
autumn colors.

Create shadows
on the ground.

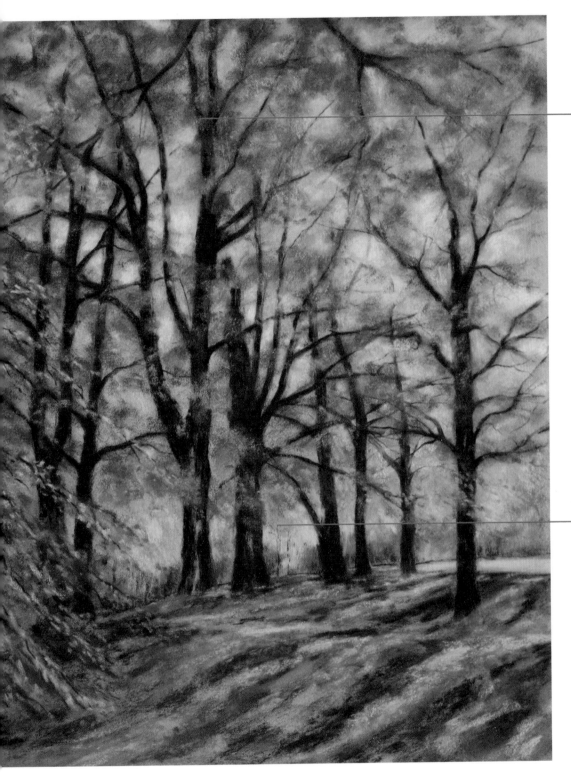

Use a combination of the sharp edge and chisel edge techniques to create small leaves on the trees, branches, and ground.

Golden yellow adds warmth.

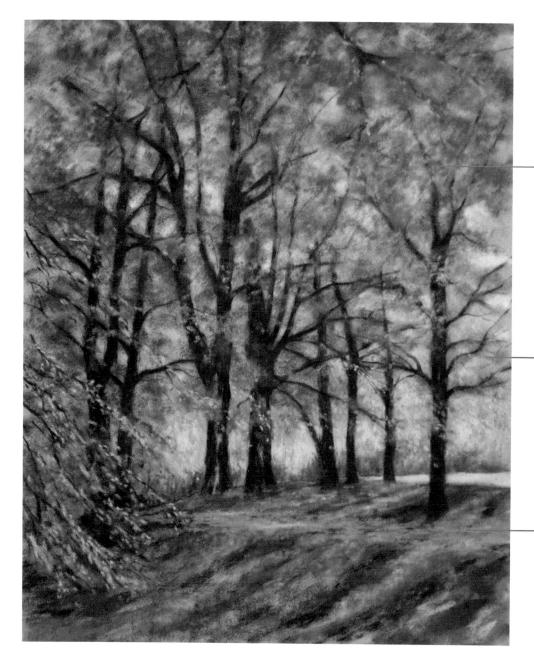

Make tiny marks on the branches and on the ground to show fallen leaves catching the sunlight coming from the right.

Fill in parts of the trees by creating groups of leaves.

Create a path using the chisel edge of the mid-gray pastel.

IMAGINE THE SUN COMING ACROSS FROM THE RIGHT SIDE OF THE PICTURE, AND SHOW WHERE THE LIGHT WOULD HIT THE LEAVES.

Use the charcoal stick to draw more branches and twigs.

Indicate more light on the leaves using the flat side and the chisel edge.

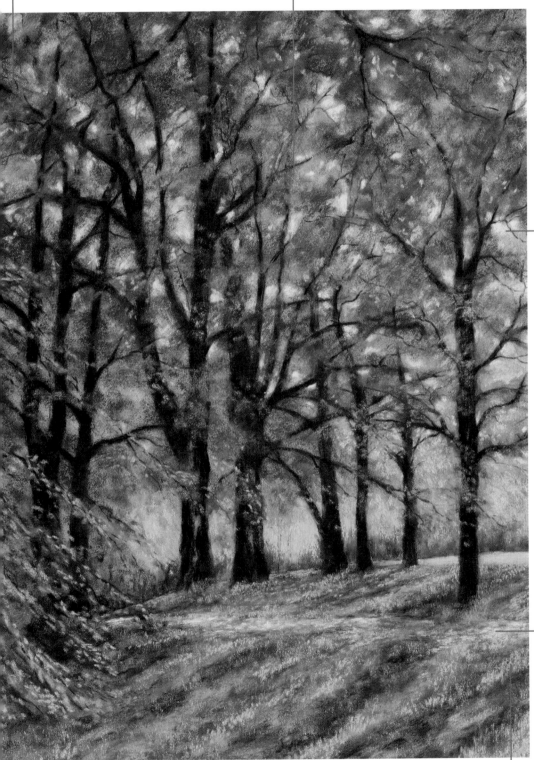

Work on the sky holes, carefully making marks to show light peeping through the clouds.

Make marks on the path to show sunlight coming through the trees.

Highlight the grass.

Depicting Twilight in Winter

The lighting on a winter evening is different than during any other season. Use blues and purples in the sky, with bright white snow on the ground.

COLOR PALETTE

Rust red, dark brown, mid-brown, tan brown, cream, forest green, pale green, golden yellow, pale yellow, pink, dark purple, mid-purple, light purple, mid-blue, pale blue, ice blue, and white

Draw the outline of the painting in a loose style.

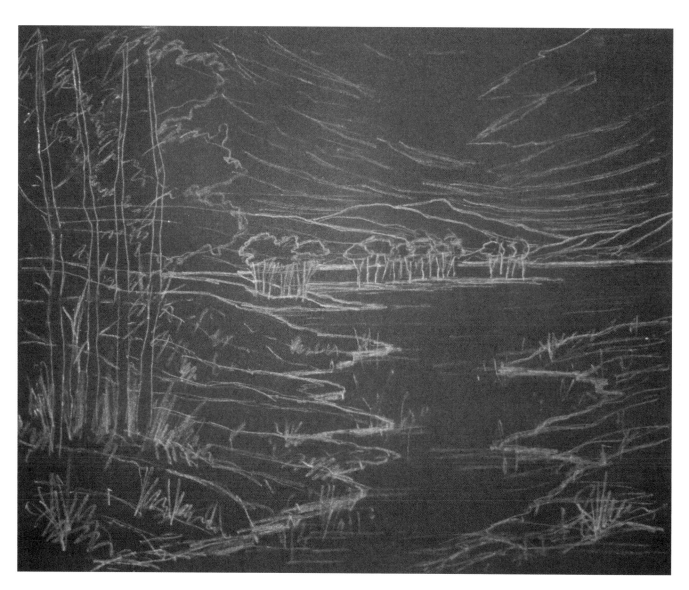

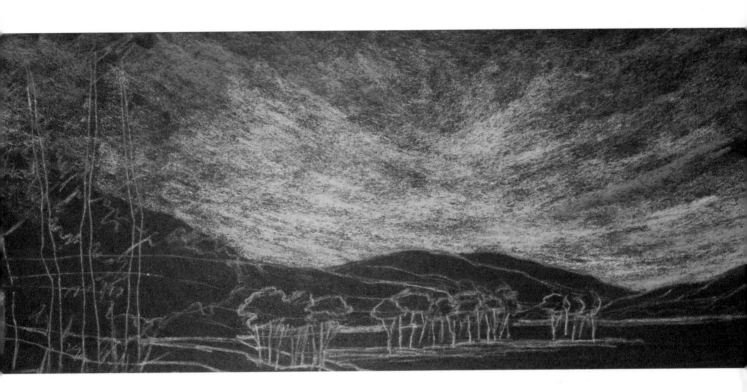

Lightly stroke thin layers of color across the sky. Note the direction of the sky as it moves toward the mountains. Leave a small gap between the mountains and the sky. Lighten up the sky with pale blue just above the mountains. Using the chisel edge of pale yellow, lightly draw along the top of the mountains. Then add a light layer of color over the pale blue areas of the sky.

Create a warm pink glow above and on top of the pale yellow. Using the chisel edge of the light purple pastel, add a light coating just above the mountain. Also add a little color to the sky above using the flat side. With dark purple, block in the mountain.

tip

CHOOSE A DARK BLUE OR GRAY SANDED CARD FOR THIS PAINTING. THOSE ARE THE PERFECT SHADES TO REFLECT THE COLORS OF SNOW AGAINST THE EVENING SKY.

Create the glow of the sun as it moves behind the mountain with the chisel edge of the golden yellow pastel. Use the flat side of the dark purple pastel to create dark shadows at the edge of the river. Also add a little color behind the trees in the distance. Place a layer of light purple to create reflections of the sky in the water. Add the mountains' reflections below the treeline in the distance.

Use the flat side of the dark brown pastel to create leaves in the trees. Create areas of pale blue snow. Add pale yellow to create the sky's reflection in the water.

Continue to add the sky's reflection in the water using the flat side of the golden yellow pastel. Now add a layer of rust red to the trees. Also place some color on the ground to indicate plants. Enhance the reflections of the sky in the water with pale blue.

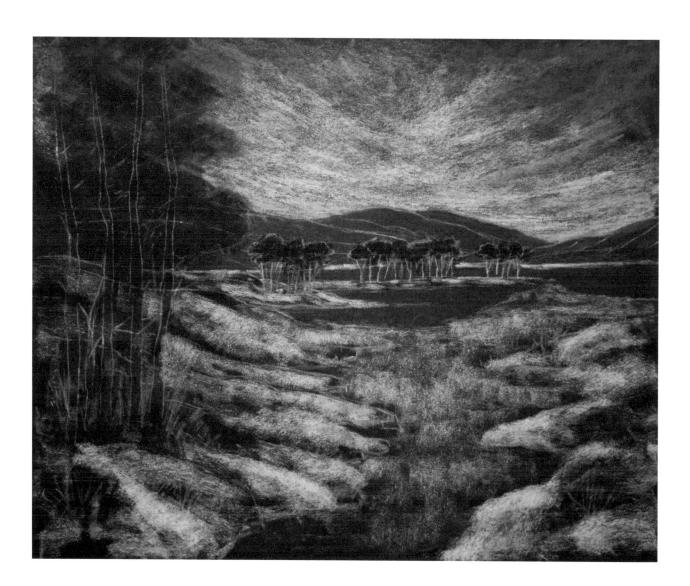

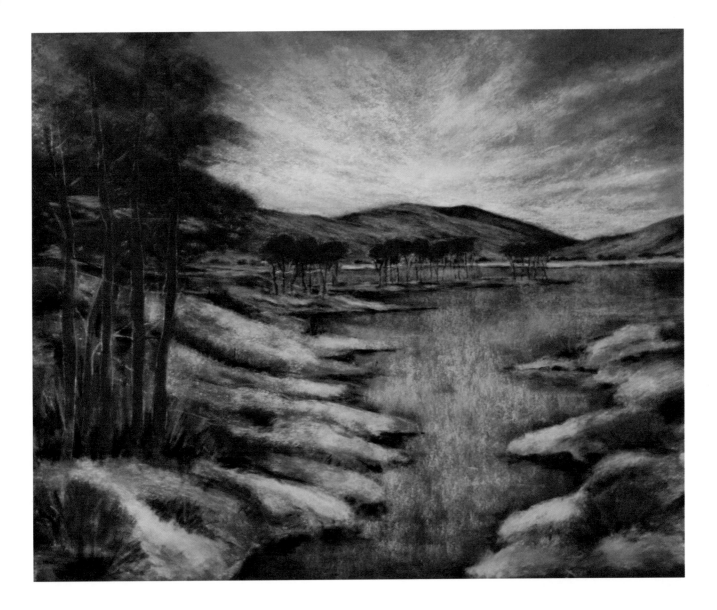

Use the chisel edge of the dark brown pastel to draw the tree trunks. Carefully blend.

Add a light layer of dark purple to the outer edges of the sky. Use pale blue pastel to lighten up the center of the sky. Warm up the tones in the sky with light purple. Now create the glow from the sun as it moves behind the mountain with the chisel edge of pale yellow. Lighten up the central area of the sky with pink.

Use the flat side of the mid-purple pastel to lighten the center of the river. Next, add light layers of purple to the mountains to indicate snow. Lighten up the reflections of the sky in the lower part of the river. Create a dark shadow on the distant mountain, edge of the river, and ground below the trees using a charcoal stick or soft black pastel pencil.

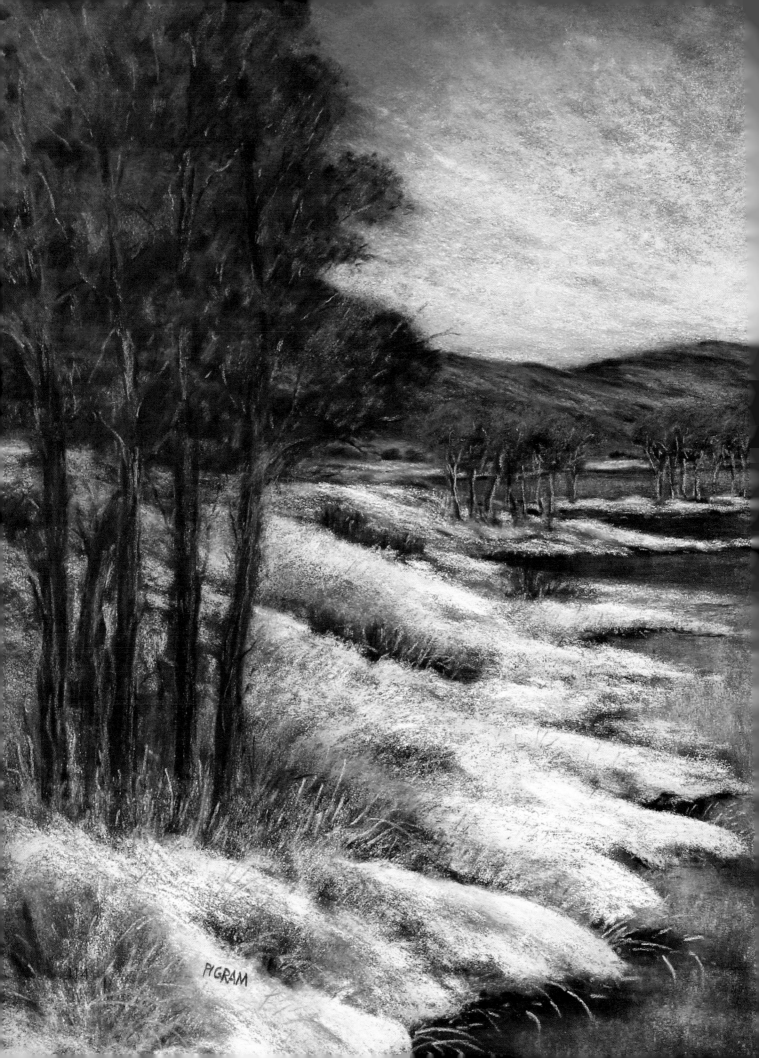

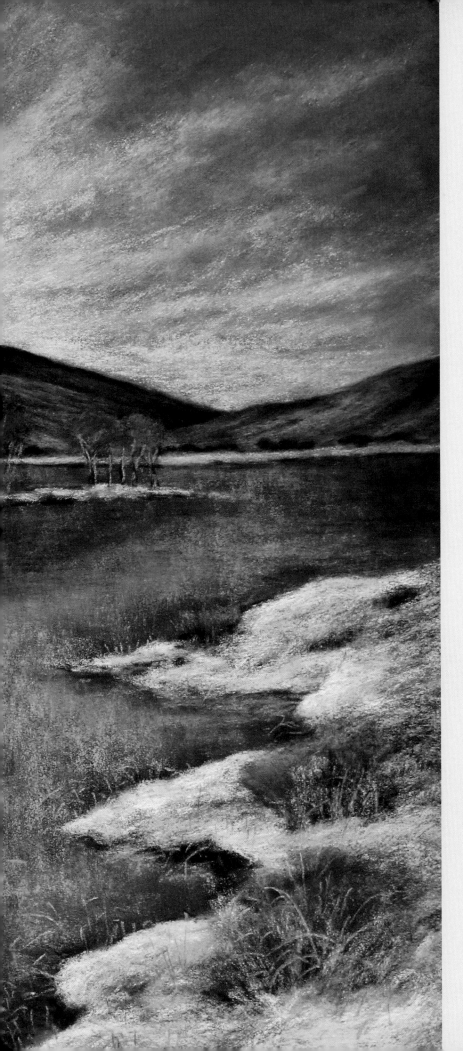

Intensify the pale blue snow on the ground. Use the sharp edge of the tan brown pastel to add flecks of light to the grasses and along the ground. Next, use the flat side to add a golden glow to the tips of the grasses to indicate light reflecting from the sun as it disappears behind the mountain. Add shades of green to the trees.

Use a charcoal stick or black soft pastel pencil to add bark to the trees and within the leaves to indicate shadows. Using the flat side of the ice blue pastel, add a light layer to the snow as it meets the water. Add tan to the trees. Use a pale gray soft pastel pencil to add light to the tree trunks and to the bark. Then create frozen grasses along the edge of the riverbank. Add bright white highlights to finish the painting.

115

Observing Winter Colors in a Landscape

When the sun hits the snow on a cold winter's day, the colors become intense with cool blues, purples, pinks, and brilliant whites.

COLOR PALETTE

Rust red, dark brown, tan brown, cream, forest green, pale green, golden yellow, pale yellow, pink, dark purple, mid-purple, light purple, mid-blue, pale blue, ice blue, and white

Loosely outline the painting using a soft black pastel pencil.

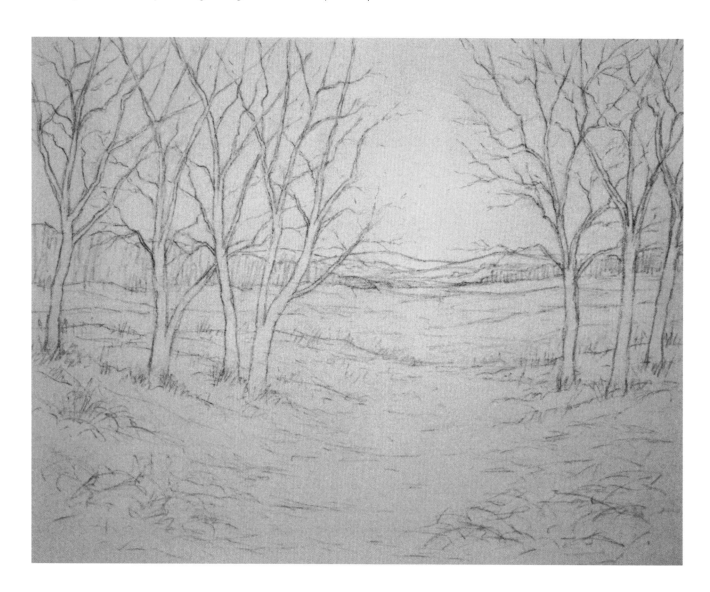

With the flat side of a pastel, paint a light layer of color across the sky.

Lighten up some areas of the sky.

Create cloud effects with white.

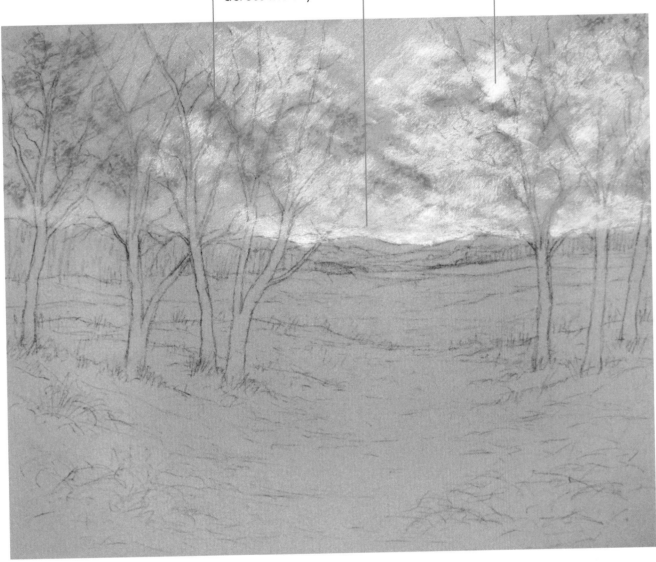

tip

WHEN CREATING SKY, PAINT AT AN ANGLE FROM LEFT TO RIGHT TO SIMULATE MOVEMENT.

Add a hint of snow
on the distant hills.

Indicate trees on
the distant hillside.

Block in the hills.

Warm up the sky.

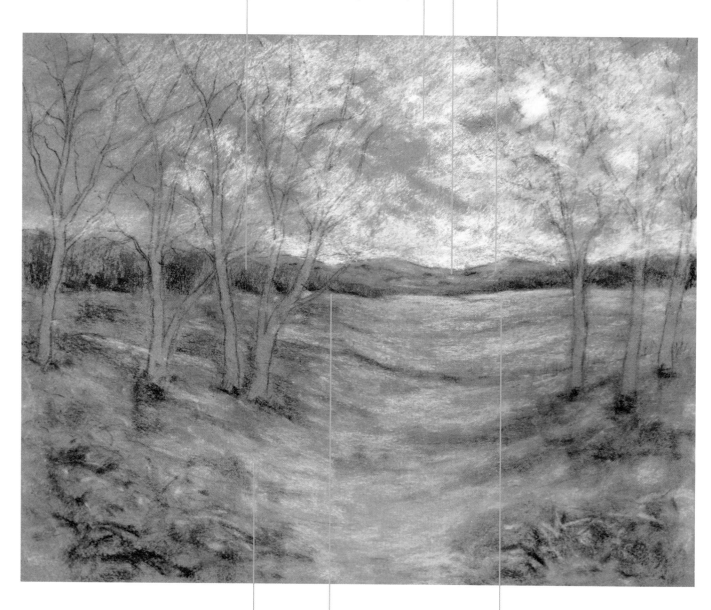

Create a hint
of sunlight
reflecting
onto the
snow.

Add darker and
lighter shadows
on the ground
with the flat side
of a pastel.

Create layers of
snow and light
and dark shadows
on the snow.

Create shadows at the base of each tree, and indicate grass and fallen branches.

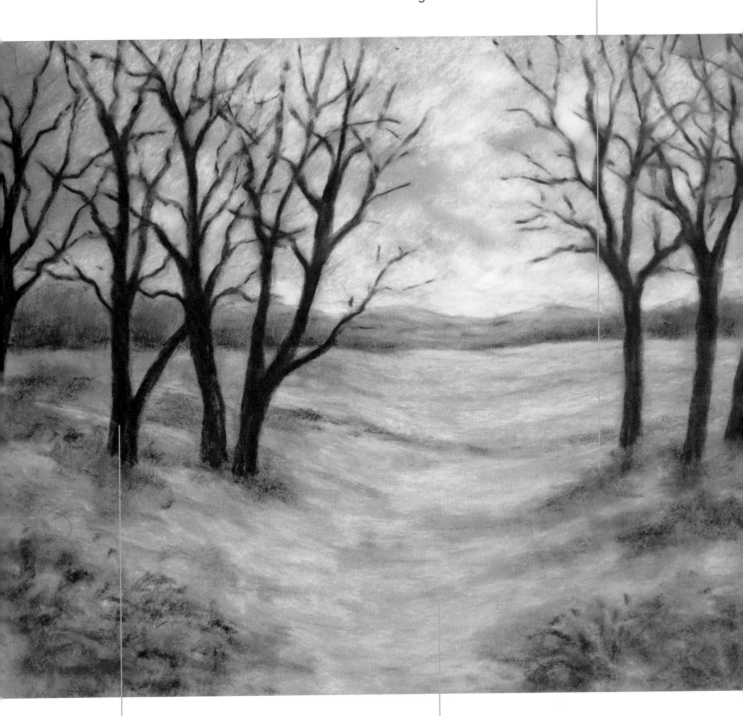

Use the sharp edge of a pastel to draw the trees and branches.

Use your fingers or a blending tool to blend all of the colors.

Add a layer to the clouds without pressing too hard on the pastel.

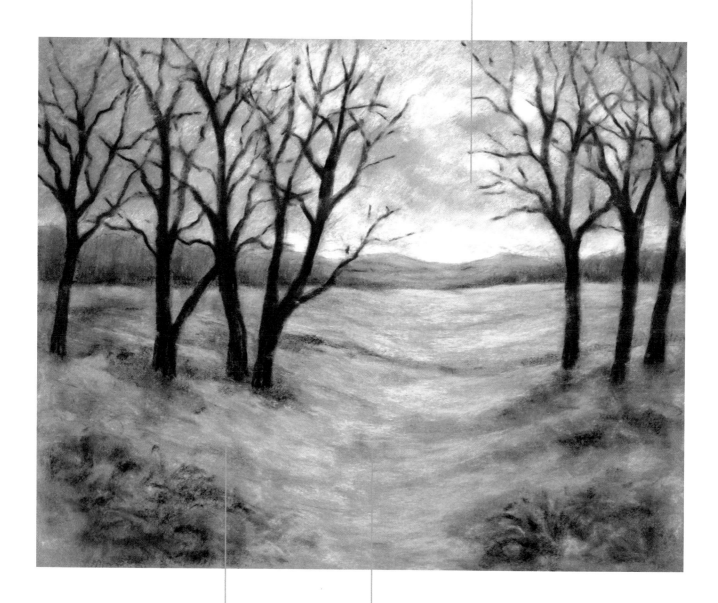

Layer more snow on the ground.

Add highlights to the snow, the hills, and the field.

Also add highlights to the trees and their branches, grasses, bases of trees, and fence posts using the sharp edge of a pastel.

Use a charcoal stick or soft black pastel pencil to create thin branches.

Create light highlights in the clouds.

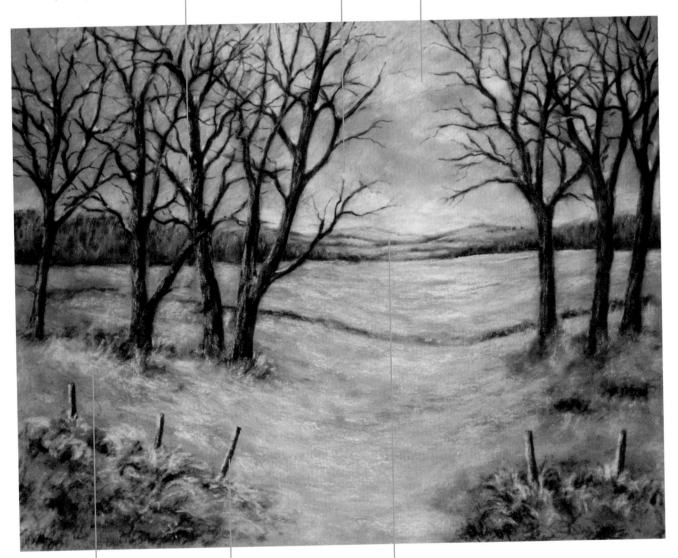

Add highlights to the snow.

Draw the fence posts.

Add highlights to the snow, the hills, and the field.

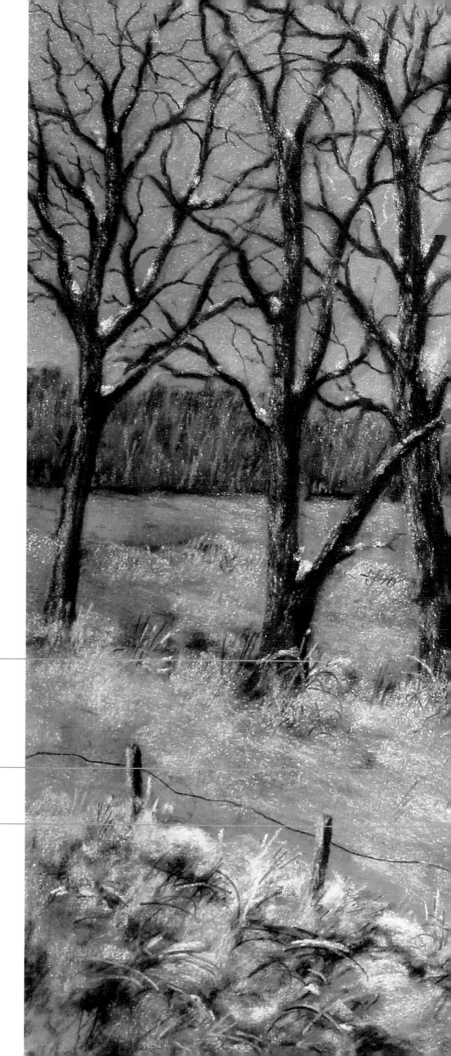

Adding frozen grass on the ground makes this scene look believably cold.

Lay bright highlights on the snow along the ground, under the trees, and along the banks.

Use a soft black pastel pencil to add a thin wire attached to the fence posts.

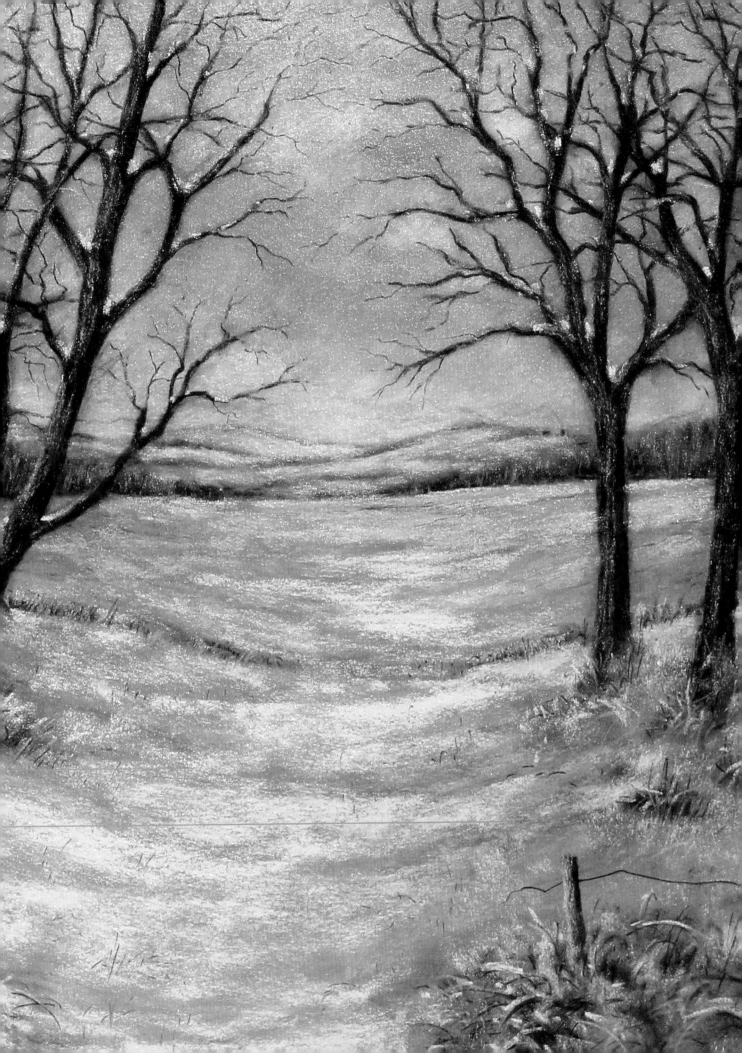

Setting Yourself Up for Success

Use these drawings for the pastel painting projects in this book as explained on pages 68-69. Copy these directly, or draw them freehand—the choice is yours! When you're ready to add color, see page 70 to begin.

"Starting with Spring," see page 70

"Painting a Springtime Landscape," see page 76

"Setting the Scene for Summer," see page 82

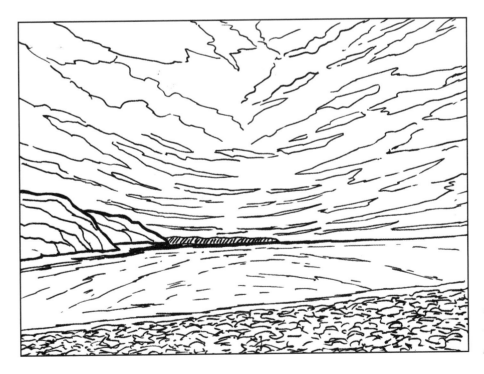

"Stunning Summer Sunset," see page 90

"Reflecting on Fall," see page 98

"Conveying Fall Colors," see page 104

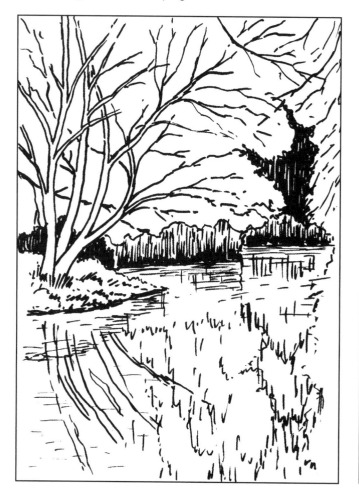

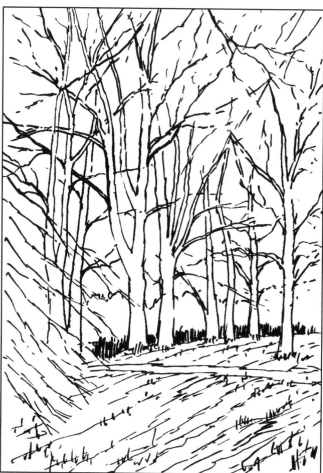

EXERCISE

Practice blending your pastels here before creating an original painting.

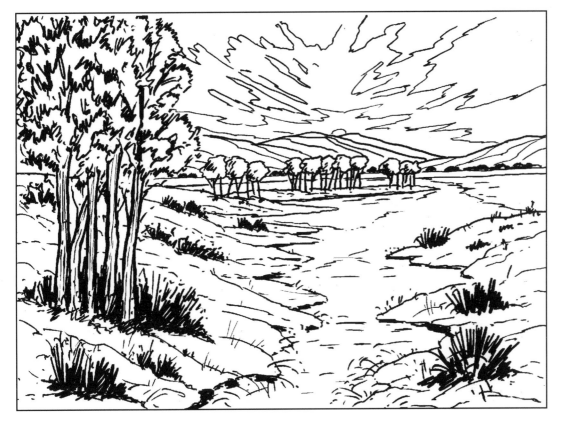

*"Depicting
Twilight in Winter,"
see page 110*

*"Observing
Winter Colors in a
Landscape," see
page 116*

About the Author

Paul Pigram originally trained in graphic design, which led him into the creative world of advertising. After a successful career, he returned to his love of painting and now works as a full-time professional artist and tutor specializing in pastel painting.

Paul has taught pastel for many years and has perfected his own techniques to capture light and shade within a painting. Working almost exclusively with soft pastels on sanded card, Paul demonstrates his techniques to art groups and societies across the United Kingdom. He also runs pastel-painting workshops throughout the year.

Paul is a professional associate of the Society for All Artists as well as a member of the North Wales Society of Fine Art.

He lives with his wife, Kate, near Snowdonia National Park in North Wales. Living within walking distance of the world-famous Bodnant Garden means having many spectacular views practically on his doorstep.

For more information, visit www.paulpigram.co.uk